IMAGES
of America

CLARKSVILLE

IMAGES
of America

CLARKSVILLE

Liana Mitchell and Joel Wallace

ARCADIA

Copyright © 2000 by Liana Mitchell and Joel Wallace.
ISBN 0-7385-0648-6

Published by Arcadia Publishing,
an imprint of Tempus Publishing, Inc.
2 Cumberland Street
Charleston, SC 29401

Printed in Great Britain.

Library of Congress Catalog Card Number: 00-107119

For all general information contact Arcadia Publishing at:
Telephone 843-853-2070
Fax 843-853-0044
E-Mail sales@arcadiapublishing.com

For customer service and orders:
Toll-Free 1-888-313-2665

Visit us on the internet at http://www.arcadiapublishing.com

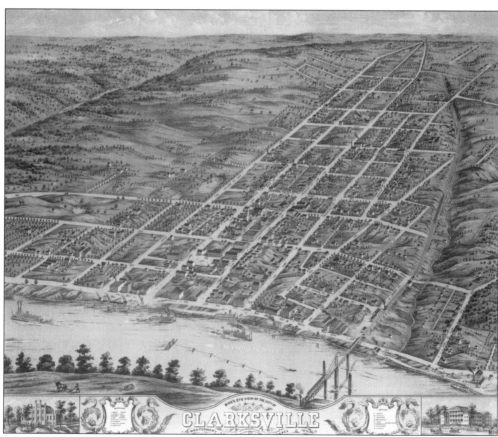

This bird's-eye-view map of Clarksville was produced in 1870. (LOC.)

CONTENTS

This book is dedicated to our families,
for the love, support, and encouragement
they have shown to us over the years.

PHOTO CREDITS

AP	Austin Peay State University Archives
LOC	Library of Congress
JH	Collection of Jeanne Holder
MB	Collection of Mary Bodnar
RC	Monroe Goodbar Morgan Archives at Rhodes College
RR	Collection of Randy Rubel
TSLA	Tennessee State Library and Archives
VU	Photographic Archives, Vanderbilt University

INTRODUCTION

It is seemingly inevitable that the faces of cities and towns change over time. Changes in the economy, disasters, or any number of other factors can lead to alterations in the appearance of an area. In this way, Clarksville, Tennessee, is no different from most American cities.

Though tobacco is still a major cash crop in the area, Clarksville is no longer the major tobacco port that it once was. Instead, a number of industries have moved into the area employing a large number of people. Over the years, disasters such as fires, floods, and tornadoes have reduced some cherished and significant buildings to rubble. Through this collection of images, we have attempted to commemorate some of the special people and places in Clarksville's past. Some of the places still exist, while others have been gone for some time.

Many of these images feature the downtown historic district as this is where the city really found its start. The many businesses on Franklin Street that have come and gone over the years and the beautiful homes and churches on Madison Street are institutions that represent and identify our community. Other photographs feature the smaller communities within Montgomery County. Although Clarksville and Montgomery County have almost become synonymous over the years, these smaller communities and their residents helped develop the unique character of our county and heritage.

Clarksville's rich past continues to stimulate a strong educational environment even today. In the early years, several private academies paved the way for the advent of the current public school system in Montgomery County and the state. Clarksvillians are fiercely proud of their college town and the various institutions that have established themselves here. It is not surprising that numerous writers, educators, and politicians have called Clarksville home.

This book is by no means a thorough look at the history of Clarksville. Over the years, a number of historians and writers have compiled in-depth histories of the area. These books are essential to understanding Clarksville, and many of them are listed in the bibliography section at the end of this book. Though nearly all of the titles are out of print, they can be found at both the Clarksville-Montgomery County Public Library and the Woodward Library at Austin Peay State University.

A number of the images in this book came from the Tennessee State Library and Archives and the Tennessee Room of the Woodward Library at Austin Peay State University. Many others were obtained from the private collections of generous friends and family members. Many of the photographs were originally from the collection of Matt Kirk. Kirk, who died in 1958 at the age of 60, was an amateur photographer who also collected images from a number of other local photographers.

7

One

TOBACCO

CLARKSVILLE'S CASH CROP

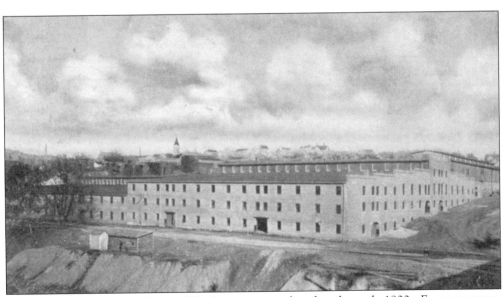

This postcard view of the Grange Warehouse was produced in the early 1900s. For many years, until the World War I era, this building was considered the largest tobacco warehouse in the world.

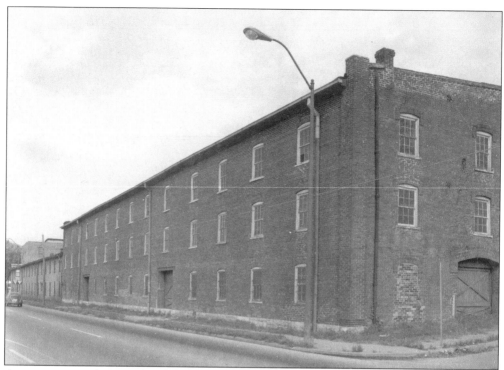

A more recent photograph of the Grange Warehouse is seen here. Originally constructed around 1858 as a planing mill, the warehouse covered nearly 3 acres of ground and had the capacity to store thousands of hogsheads of tobacco. (LOC.)

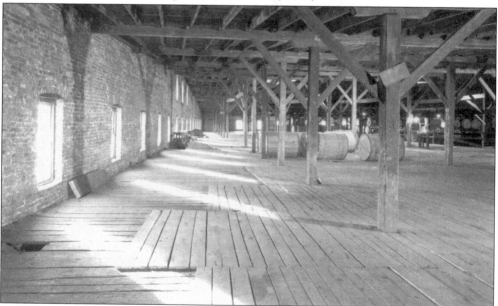

The Grange Warehouse featured two distinct parts or levels. The bottom floors, which fronted Adams Street, were known as the Lower Grange. The top floors, which fronted Washington Street, were referred to as the Upper Grange. This interior photograph was taken in the Upper Grange. (LOC.)

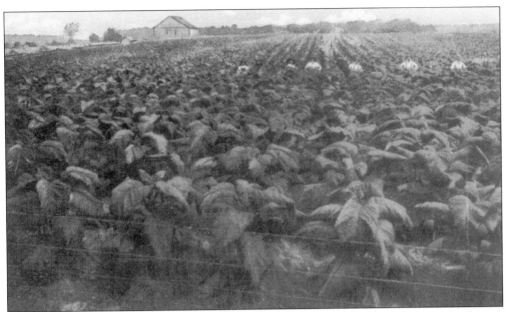

This postcard depicts a typical tobacco field in the Clarksville area. Note the men standing in the middle of the field and the presence of the barn in the background. (TSLA.)

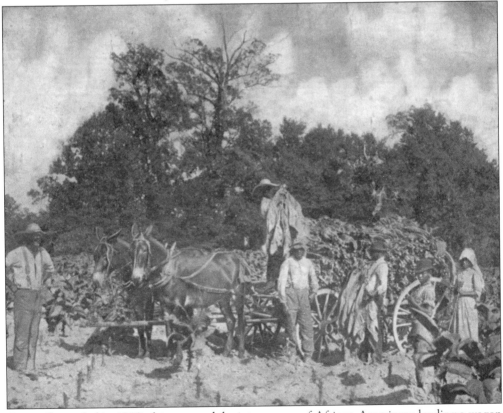

Originally mailed in 1909, this postcard depicts a group of African Americans loading a wagon with tobacco to be taken into Clarksville for sale.

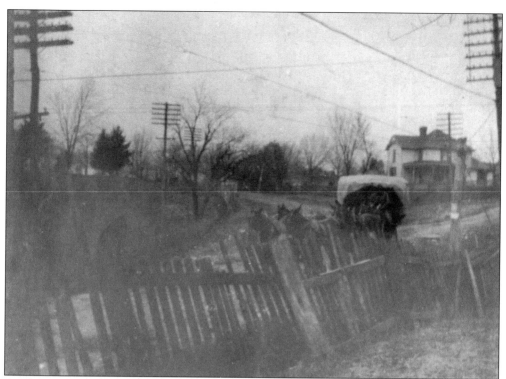

Taken around 1910, this photograph shows a wagon loaded with tobacco being moved down Boot Hill toward Clarksville. (TSLA.)

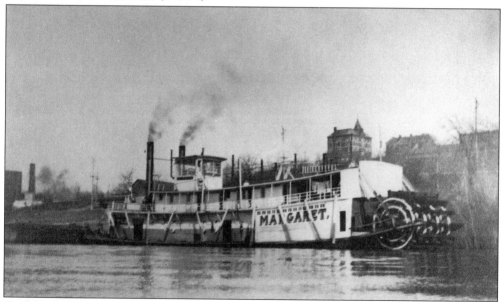

To the right and behind this paddlewheel boat is the Tobacco Exchange building. Because of its location on the Cumberland River, Clarksville was an ideal shipping point for tobacco growers. Beginning in the early 1800s, tobacco was placed on flatboats and floated down the river to New Orleans. Around 1840 faster steamboats replaced flatboats as the means of transporting tobacco. (TSLA.)

The Clarksville Tobacco Exchange was established in 1855. The Tobacco Exchange building, located near Public Square, was built in 1878–1879 at a cost of approximately $20,000. The massive four-story structure served as both a marketplace for tobacco, drawing buyers from around the world, and a social hall, where many balls were held. Near the turn of the century, the exchange method of selling tobacco gave way to the practice of selling tobacco in loose floor warehouses. By the 1930s, the building was no longer needed and was torn down. (TSLA.)

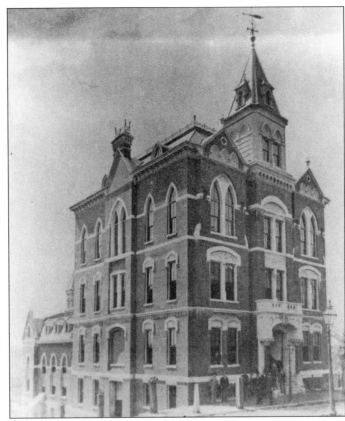

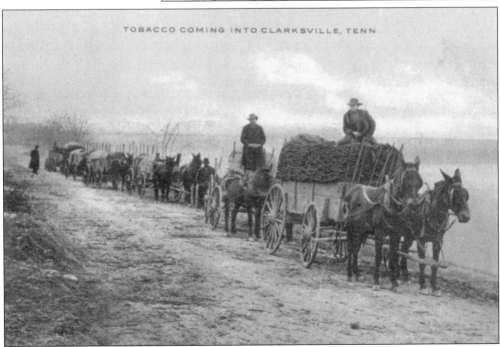

This postcard shows wagons loaded with tobacco coming into Clarksville along Front Street.

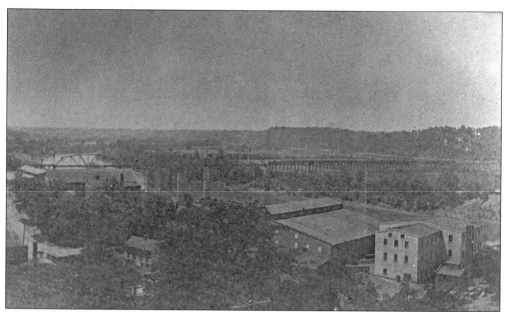

The four-story Elephant Warehouse is seen in the center of this photograph. The building was constructed in 1868 by the firm of Turnley and Wooldridge. At the time of its construction, it was the largest tobacco warehouse in the South; it lost this distinction when the Grange Warehouse was built. (TSLA.)

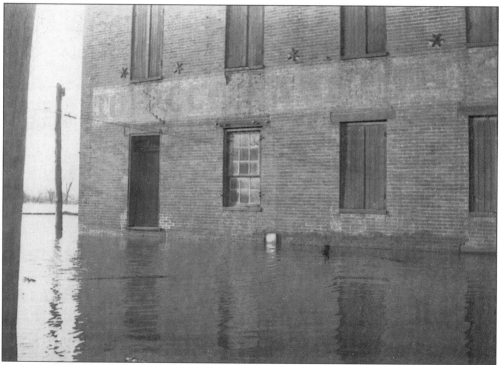

The Elephant Warehouse, which was located along Front (later Riverside Drive) and Commerce Streets, was photographed during the Flood of 1937. (MB.)

The J.W. Rudolph & Brothers Loose Floor Tobacco Warehouse was located at the corner of Jefferson and First Streets on the current site of Legends Bank. (AP.)

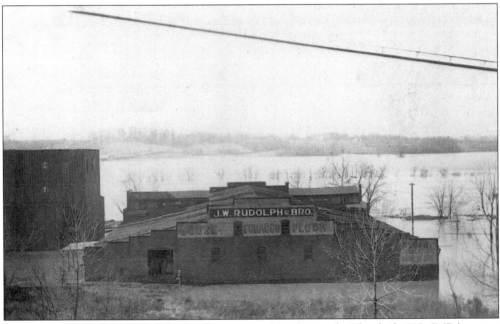

This photograph of the Rudolph Warehouse was taken during the Flood of 1927. (MB.)

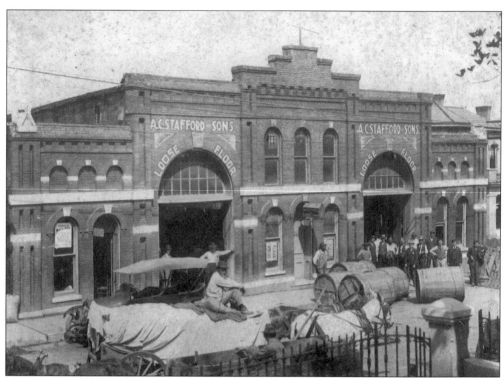

This building, constructed in 1886, was located at the corner of Main and North Second Streets and was originally used as a livery stable. It was later converted into the A.C. Stafford & Sons tobacco sales floor. (MB.)

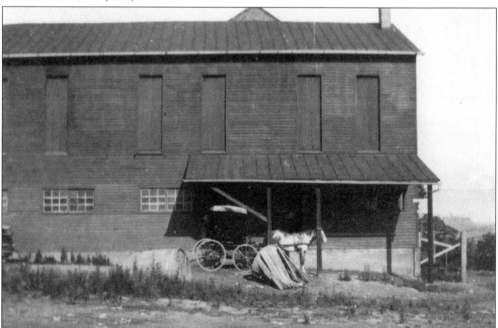

This tobacco warehouse was located on High Street. Photographed around 1915, it was owned by Christopher Smith, who also owned the Smith-Trahern mansion. (TSLA.)

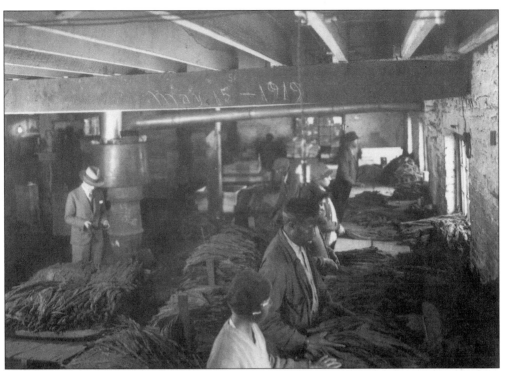

In this 1919 photograph of the interior of a loose floor warehouse, tobacco is sorted and graded according to quality. A tobacco buyer is in the background. (AP.)

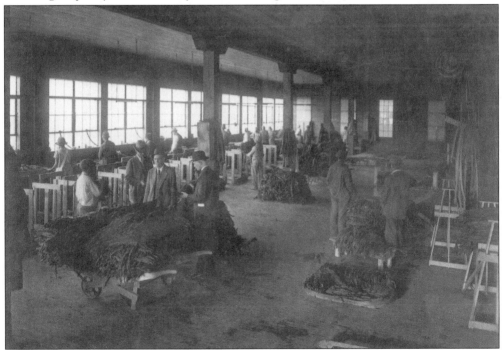

Tobacco is sorted in another loose floor warehouse. The windows in this building provided the ample source of light that was necessary to properly grade tobacco. (AP.)

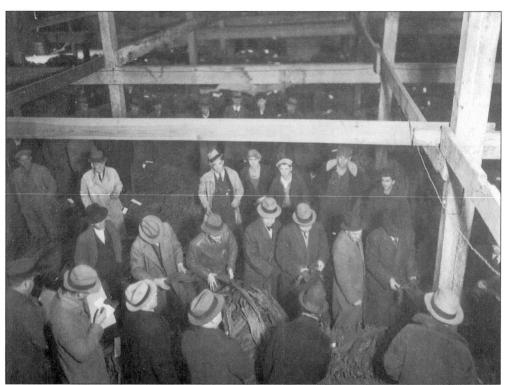

A large group of tobacco buyers is pictured at the 1936 opening of the Clarksville Loose Floor Warehouse. (AP.)

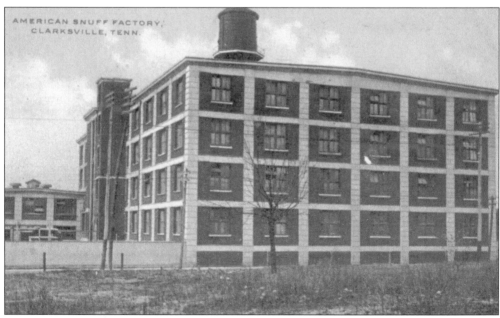

The American Snuff Factory stands at the corner of Tenth and Commerce Streets. It was constructed in 1906 at the beginning of the Clarksville area's entrance into manufacturing.

Two

LANDMARKS

SIGHTS FROM CLARKSVILLE'S PAST

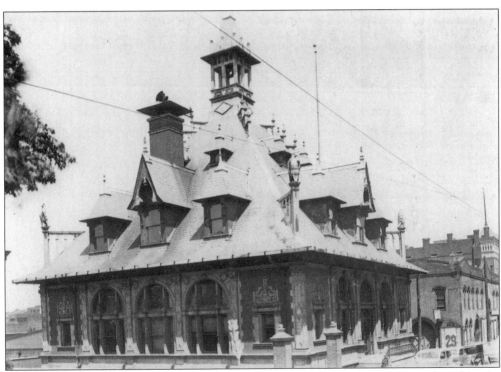

Originally built as an ornate United States Post Office in 1898 and in 1936 purchased by the city of Clarksville, the Clarksville-Montgomery County Museum building sits at the southwest corner of Commerce and South Second Streets. Architect William Martin Aiken, the supervising architect of the United States Treasury Department, designed the building. Aiken designed the brick walls and slate roof to fireproof the building. (AP.)

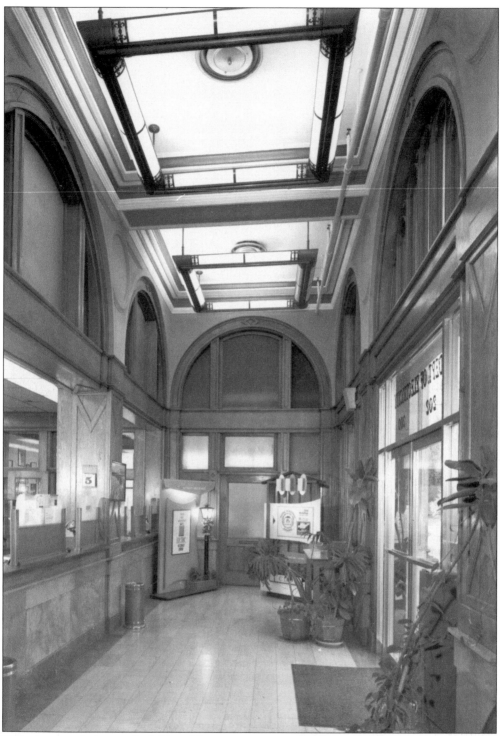

This photograph depicts the lobby of the present museum building as it appeared when it served as the headquarters of the Clarksville Department of Electricity. (LOC.)

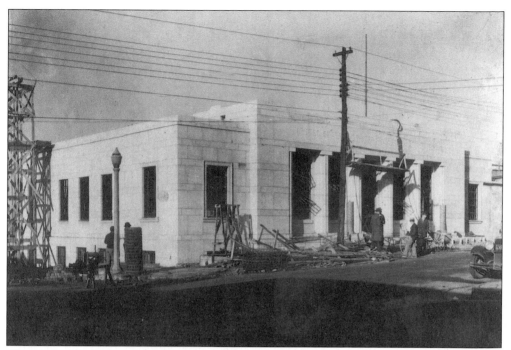

The current downtown federal building, located at the corner of Second and Legion Streets, is shown in this photograph during its construction in 1935. It was built as a United States Post Office. (MB.)

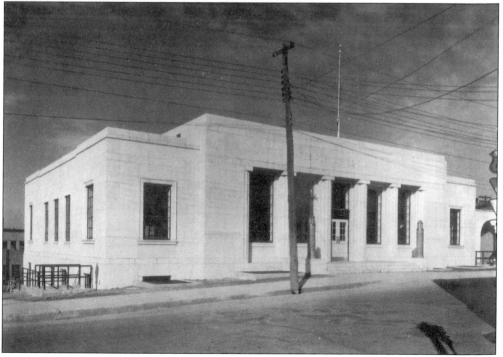

A completed United States Post Office is pictured here in 1936. The new post office was built to provide more space for the larger amounts of mail being delivered to the area. (MB.)

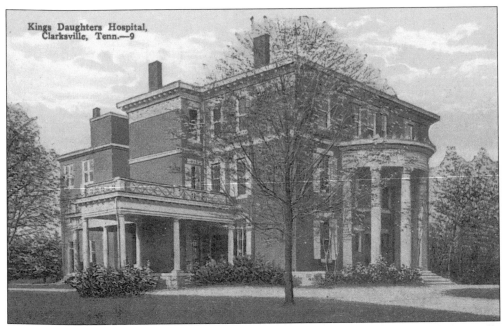

Kings Daughters Hospital, Clarksville, Tenn.—9

For 27 years this building on North Second Street served as the Clarksville Hospital. Originally the home of W.B. Anderson, it was purchased by the city in 1927. In 1929 the Edith Pettus Memorial Home for Nurses was a new addition to the facility. After the opening of Memorial Hospital in 1954, the building was used by the Clarksville Academy until it was razed to make way for a new building. (AP.)

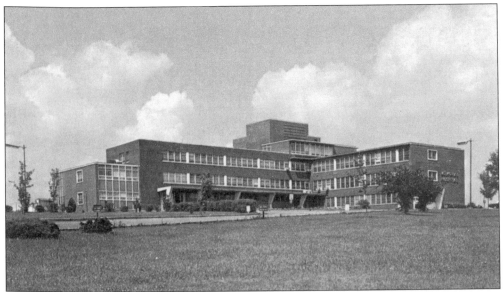

Memorial Hospital opened in 1954 at 1771 Madison Street. The building was constructed at a total cost of $2.5 million. One-fourth of the building cost was generously donated by the estate of Howard D. Pettus. The new hospital was equipped with 105 beds, a blood bank, and modern air conditioning. Since the construction of the building, a number of additions and renovations have taken place, and in 1999 the facility was renamed Gateway Health System. (TSLA.)

Dr. Robert Tecumseh Burt, an African American and Mississippi native, came to Clarksville in 1904 after his graduation from Meharry Medical School and five years of medical practice in McMinnville. On March 6, 1906, he founded the first hospital in Clarksville, known as the Home Infirmary. The hospital was intended as a facility for African Americans during surgery and operations. Dr. Burt was a well-trained surgeon and continued his post-graduate training at facilities such as Harvard and the Mayo Clinic. He was skilled at abdominal surgery and performed regular cesarean sections, even before the operation became standard procedure. Burt High School was named in his honor. (AP.)

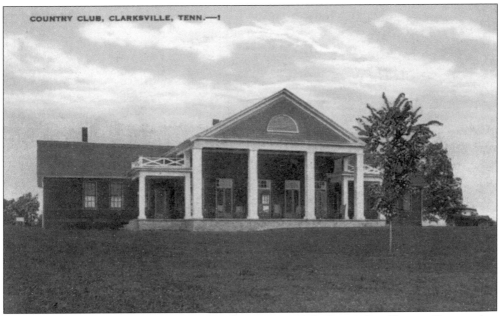

Golf and parties take place at the Clarksville Country Club. Located on Fairway Drive, it has long been a favorite of the area's socialites. (AP.)

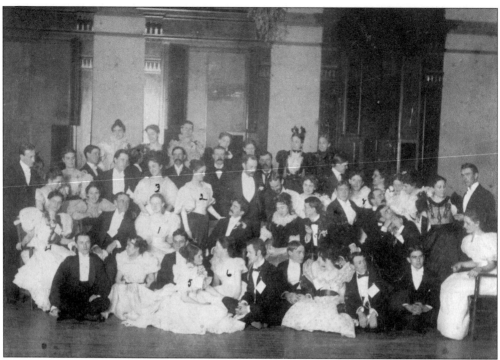

Various social clubs were organized in Clarksville starting as early as the 1860s. The Euchre, Cotillion, and Elegante Clubs are examples of some of the groups that formed during this time period. Pictured here is a debutante ball at the courthouse in 1897. (TSLA.)

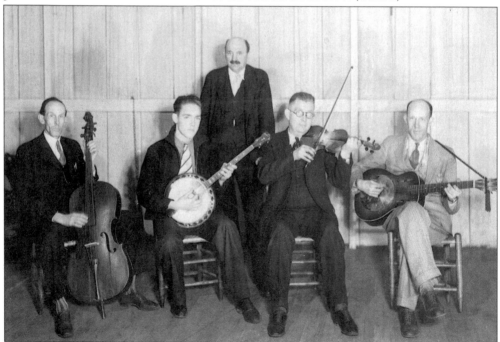

Live music was often used to entertain guests at social functions. This local group was photographed playing at a function in the courthouse. (MB.)

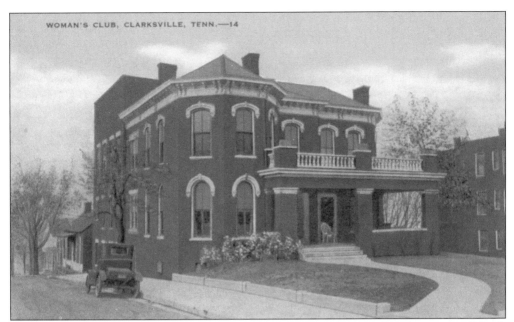

Known to many as the old Women's Club building, this structure stood at the corner of North Second and Main Streets until it was razed to make way for the First Federal Savings and Loan Association in 1960. Originally the J.C. Couts home and also the location of the first Clarksville-Montgomery County Public Library, this building was home to the Elks Club before it was purchased by the Clarksville Federation of Women's Clubs in 1918.

Located at the corner of North First and Main Streets, the Electric Light building served as the city's first electric power plant. (AP.)

25

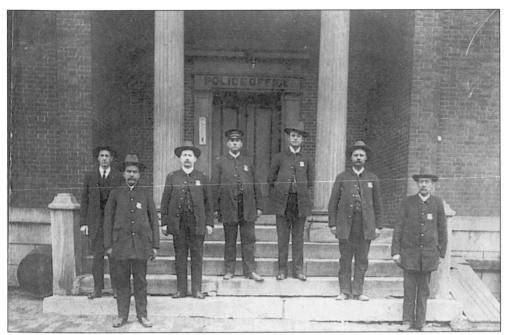

An early Clarksville Police Department poses for a photograph outside of their headquarters in the late 1800s. (MB.)

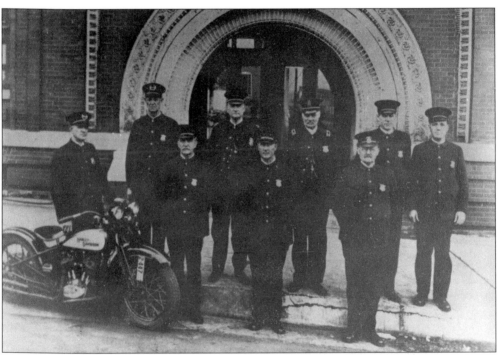

The Clarksville Police Department was located on Public Square in the present City Hall Building. Appearing in this 1930s photograph, from left to right, are (front row) A.D. Curtis (behind motorcycle), Alex Small, T.E. Huggins, and R.E. Binkley; (back row) J.W. Baggett, Chief J.E. Robinson, J.O. Ellarson, Jerry Lee, and J.P. Balthrop. (TSLA.)

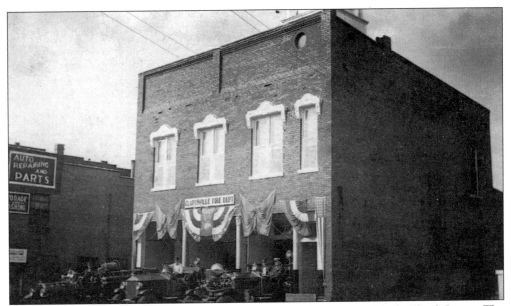

This 1934 photograph depicts the Clarksville Fire Department on South Third Street. The station is decorated for Clarksville's sesquicentennial. This building was razed in 1938, and a new station was built on the same site. (AP.)

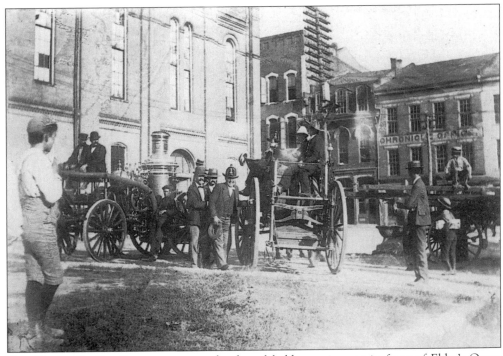

The Clarksville Fire Department tests hook and ladder equipment in front of Elder's Opera House. (MB.)

The Knights of Pythias building is pictured here in the 1920s at its location on the corner of Franklin and Third Streets. The Knights of Pythias is a fraternal organization that was founded in 1864. (TSLA.)

The Odd Fellows Home provided care for the elderly as well as young children in need. The home was actually a collection of three buildings and was operated from 1898 to 1946 by the International Order of Odd Fellows. Two of the organization's buildings, which were situated in the New Providence area, are visible in this undated photo. Note the insignia of the organization atop the building on the left. (AP.)

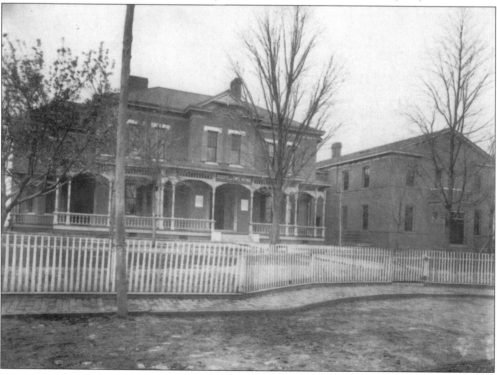

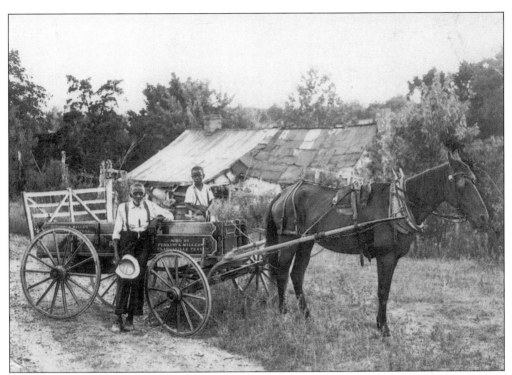

An African-American family is pictured here in New Providence with a new wagon. Supposedly, the wagon was a gift from a friend that the man, pictured here, received shortly before his own death. (MB.)

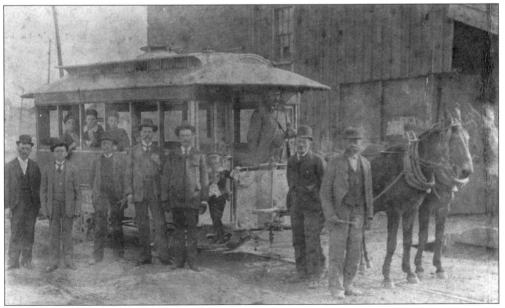

The Clarksville Street Railway Company began service with mule-drawn cars on December 15, 1885. In the early years, the route began at Public Square then proceeded down Franklin Street to Tenth Street and ended at the Louisville and Nashville (L&N) Railroad Train Depot. (TSLA.)

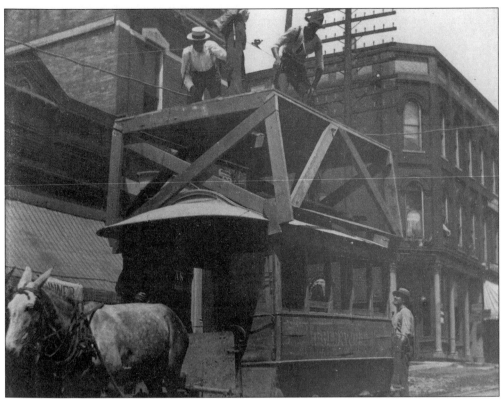

Prior to 1896, the city's streetcars were pulled by mules. At that time, an electric streetcar line was put in place. This photograph shows the line being installed along Franklin Street. (MB.)

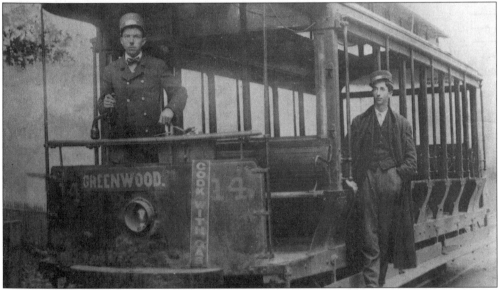

The new electric line was designed to be more cost effective. The Clarksville Railway Company purchased six new streetcars in June 1896 and began immediate installation of the new lines. Routes were added from Madison Street down Greenwood Avenue, as is advertised on the streetcar above. (MB.)

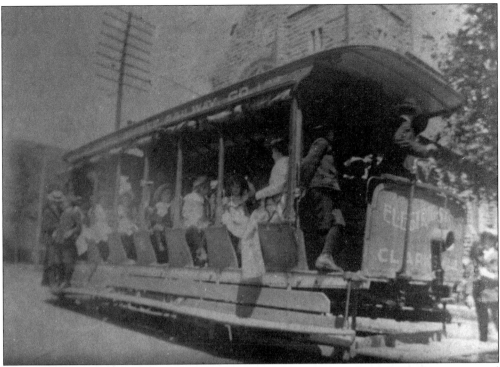

On August 22, 1896, a 5-mile route from Greenwood Cemetery to Porter's Bluff was open and functioning. The grounds at Porter's Bluff were cultivated into a park and named after Captain John F. Shelton. (TSLA.)

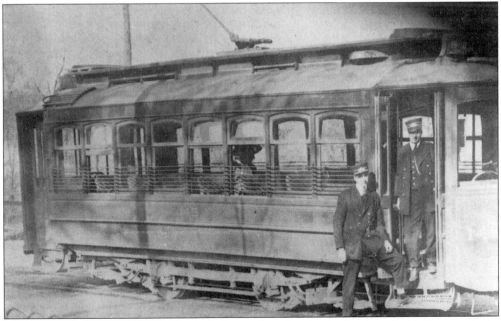

A winterized streetcar is pictured here. It featured enclosed sides for warmth. Unfortunately, by 1928 Clarksville had experienced so much growth that the transit system was no longer able to service such a wide area and ceased operation. (MB.)

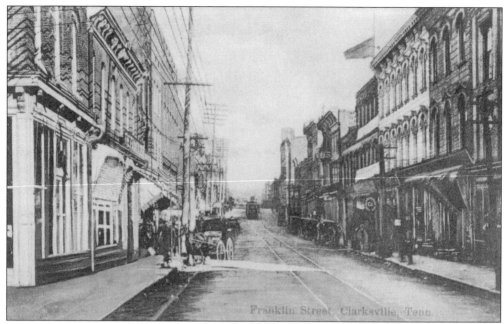

Franklin Street has long been a major thoroughfare of the downtown district. Early in the history of the community, the street contained many majestic homes. Businesses, offices, stores, and theaters have long since occupied this block. (TSLA.)

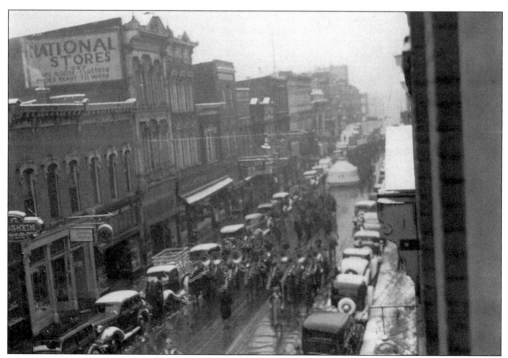

The Thanksgiving Day Parade in 1936 is seen marching down Franklin Street. The Clarksville High School band and football players are among the parade participants on this snowy day. (MB.)

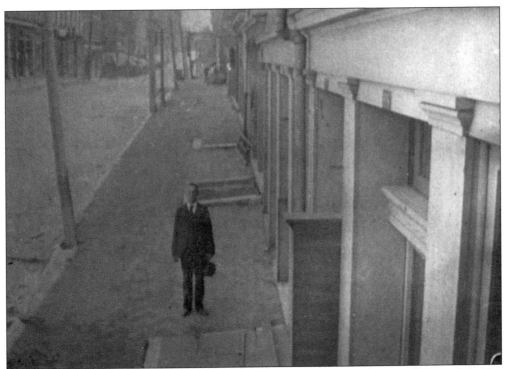

This lone, unidentified businessman was photographed during his solitary walk down Franklin Street during the 1890s. (TSLA.)

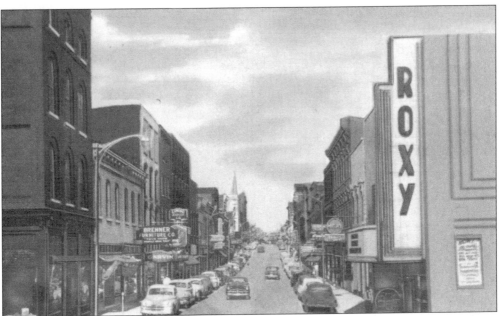

This postcard features an eastward view of Franklin Street during the 1950s. The current Roxy Theatre is located on the corner. Kleeman and Company meat market is located in the building next door to the Roxy. The site of Kleeman's is now a parking lot. Brenner's Furniture Company is located on the opposite side of the street.

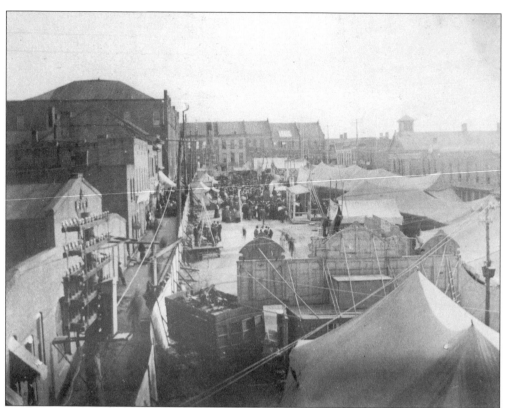

As in any community, Public Square in Clarksville was a place to gather and enjoy the company of others. Throughout Clarksville's history, major businesses and offices have always occupied Public Square. Pictured here is a carnival on Public Square in 1903. (TSLA.)

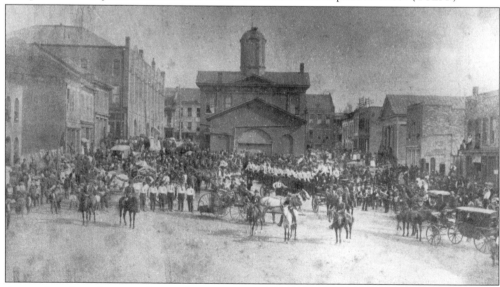

A parade takes place on the southern section of Public Square. The large building in the background is the Market House, named for the farmers and merchants who sold produce and goods on the ground floor of the building. The city council met on the second floor. (TSLA.)

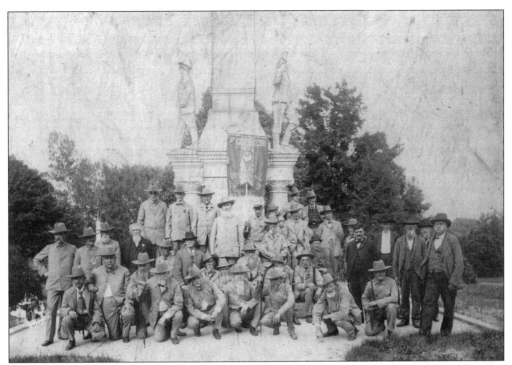

This Confederate monument is located in Greenwood Cemetery and was unveiled on October 25, 1893. The monument is made of Vermont granite and was built at a cost of $7,500. A bronze infantryman, modeled after Clarksville Civil War veteran W.R. Bringhurst, tops the monument. Adorning each side is a cavalryman and artilleryman modeled after Clarksville Civil War veterans Clay Stacker and Charles H. Bailey, respectively. In this photograph, a reunion group of veterans known as Forbes' Bivouac is seen posing in front of the monument. (MB.)

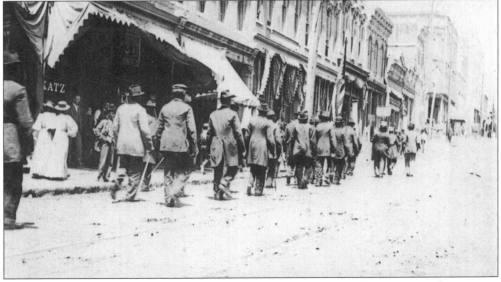

The first annual reunion of Confederate veterans occurred on October 4, 1888. The veterans are marching down Franklin Street. (MB.)

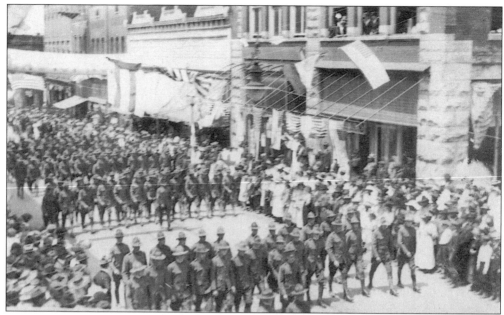

In 1918 Armistice Day was not celebrated because many troops were still away with World War I. Instead, a parade was held on May 15, 1919. The theme for the day was "Blow the Whistles; Ring the Bells; Honk the Horns." Veterans from World War I, the Mexican conflict, the Spanish-American War, and the Civil War were honored. (MB.)

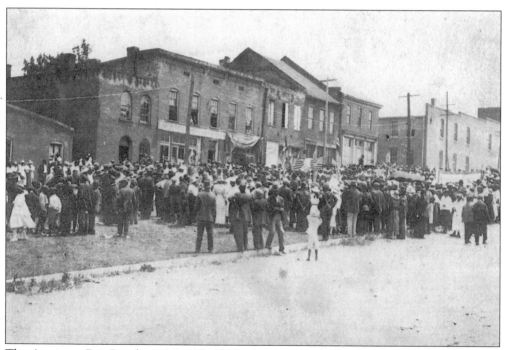

The Armistice Day Parade on May 15, 1919, was segregated. The Negro Servicemen's Parade occurred on Public Square. The African-American soldiers from World War I were welcomed during this pictured homecoming parade. (MB.)

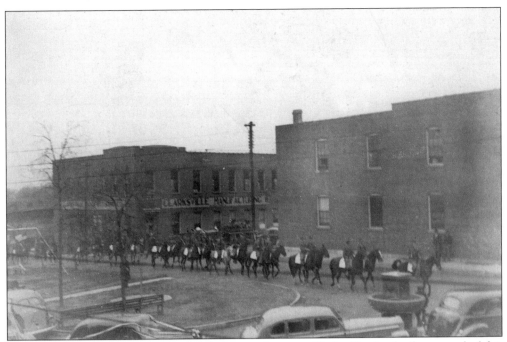

The Armistice Day Parade continued to be a tradition in Clarksville. In the foreground of this November 11, 1937, parade photograph is one of the two water fountains located on Public Square during the early 1900s. One of the fountains is now located at the Montgomery County Fairgrounds. The Mason-Hughes building, home to an early cigar factory, is visible in the background. (MB.)

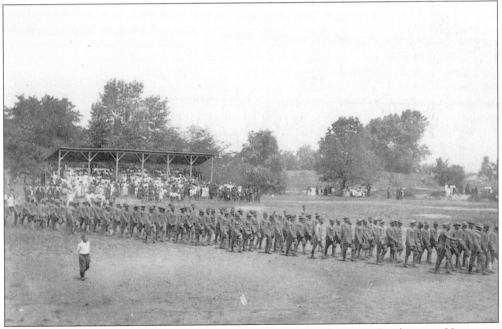

African-American soldiers are pictured here marching at Southwestern Presbyterian University (SPU) in 1918. (AP.)

This photograph was taken in the early 1860s at Trice's Landing, below Fort Defiance, on the Cumberland River. Fort Defiance was part of the Confederate defense system during the Civil War, at which time this photograph was taken. After the fall of Fort Donelson, Fort Defiance was abandoned. Union troops then had complete control of the Cumberland Valley. The area is located on the New Providence river bluffs, and remains of the landing are still present today. (TSLA.)

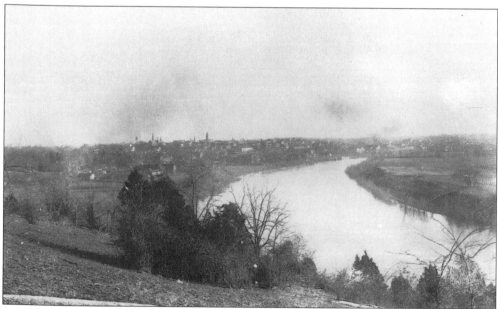

Clarksville has long been a picturesque community as is evident in this postcard. It is interesting to note the tremendous growth that has taken place during the long history of this once small town on the Cumberland River. (MB.)

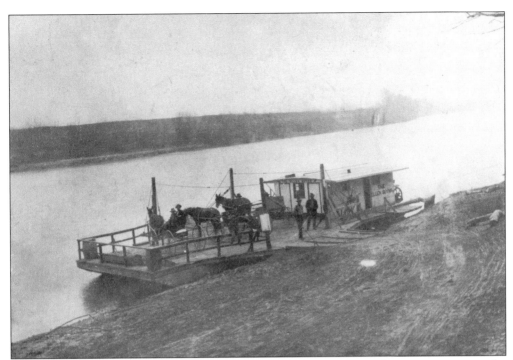

An early 1900s ferry, the *Ellen Guynn* carries horses, carriages, and passengers across the Cumberland River. (TSLA.)

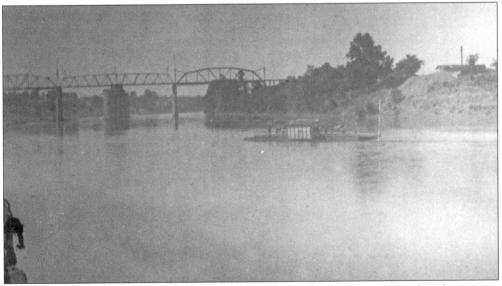

This Clarksville wharf boat functioned during the early 1900s and was located at the western end of College Street. The primary owner and operator was Frank P. Gracey, a business giant in the shipping industry. The wharf boat was anchored to the bank and would help with the loading and unloading of steamboats. In 1927 the wharf boat broke loose of its mooring and was destroyed. (TSLA.)

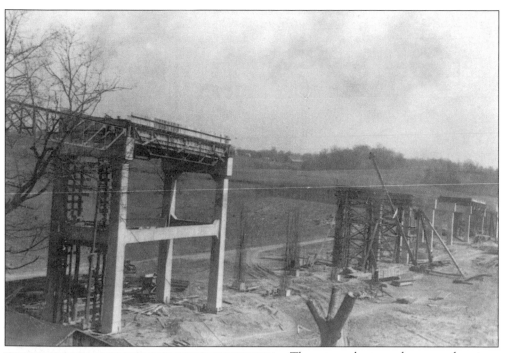

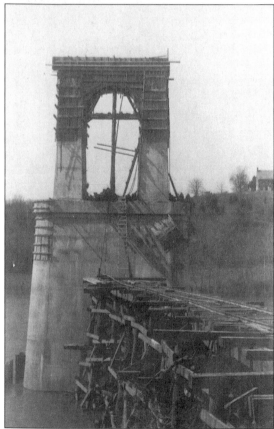

These two photographs were taken in 1923 during the construction of the John T. Cunningham Memorial Bridge on old State Route 13. Construction began on the bridge in 1922 and did not end until 1925. It was named after the prominent Clarksville politician who made the bridge possible. (MB.)

This photograph of the completed John T. Cunningham Memorial Bridge was taken in 1927. The bridge was the first major Federal Aid project in Tennessee. The construction of the bridge is significant because it was one of only two K-truss bridges in the state. (MB.)

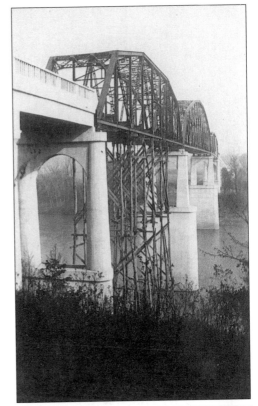

This dual-lane covered bridge was built at the Little West Fork Creek, a part of the Red River system, at Ringgold in 1856 by a Mr. Humpernaugh. Constructed of yellow poplar and white oak, the bridge was 100 feet long, and each lane was 15 feet wide. This photograph was taken in the 1930s. The bridge was considered unique for having two lanes under the same roof, and it served the area until 1946. (TSLA.)

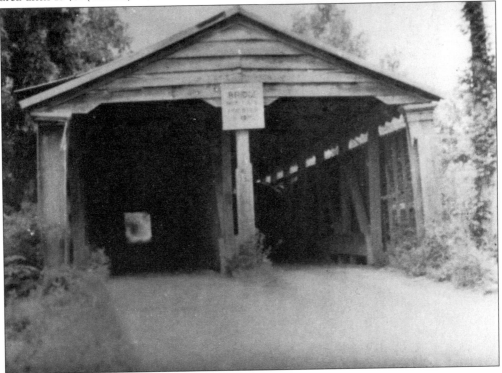

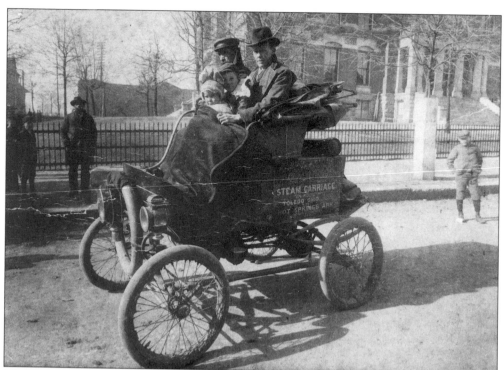

The first automobile to be seen on Clarksville streets came through town on January 10, 1902, on its way to Hot Springs, Arkansas. The driver and passengers in the car are members of the Gill family. This Ford Steam Carriage is pictured on South Third Street in front of the Montgomery County Courthouse. (TSLA.)

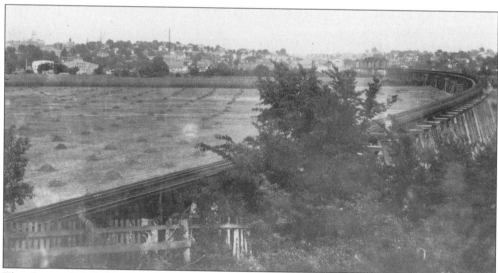

The first railroad line in Clarksville was the Memphis, Clarksville, and Louisville line. However, service stopped with the beginning of the Civil War. In 1870 the Louisville and Nashville Railroad bought and began to use the existing railway line. Passengers from Clarksville who wanted to travel to Nashville would have to change trains at Guthrie, Kentucky. (MB.)

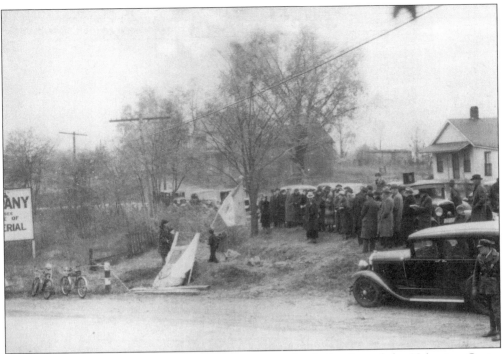

This photograph, taken during the 1920s, captures the dedication of the Valentine Sevier memorial. Sevier was an early settler of the Clarksville area and the brother of John Sevier, the first governor of Tennessee. The William Edmiston chapter of the Daughters of the American Revolution paid for the memorial. (RR.)

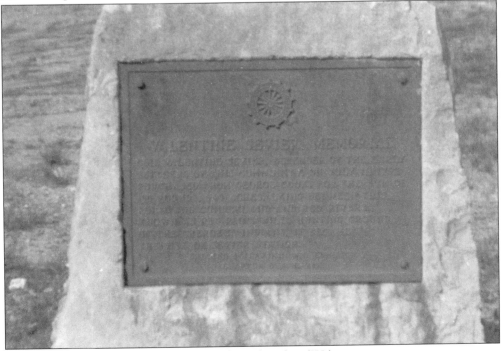

The plaque honoring Valentine Sevier still stands today. (JH.)

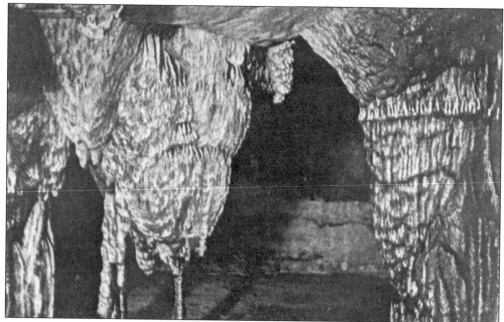

This postcard of the Independence Hall cavern shows some of the majestic qualities of Dunbar Cave, which is the largest known cave on the Western Highland Rim of Tennessee. Dunbar Cave is a "blowing" cave, meaning that the cave provides a natural cooling effect. This has often made the cave a popular tourist spot. The cave is named for Thomas Dunbar, an early settler, who in 1791 claimed the property surrounding the cave. (TSLA.)

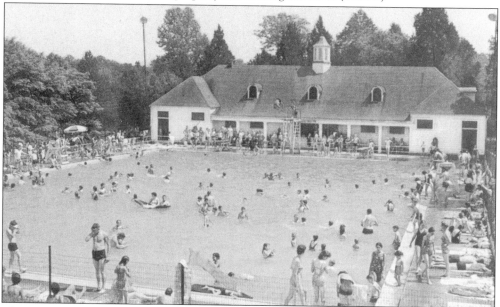

The Dunbar Cave swimming pool was an attractive feature added to the nature area by a group of Clarksville businessmen in 1931. They were part of a group that formed the Dunbar Cave and Idaho Springs Corporation, whose primary goal was to develop the area as a resort. When various city pools were opened in the late 1960s, the Dunbar Cave pool was closed and filled. The bath house was later converted into a state visitor center and museum.

During the 1930s and 1940s, Dunbar Cave was a hot spot of social activity. These young girls are pictured on the concrete dance floor near the concession stand. The railed terrace above the concession stand is visible in the background.

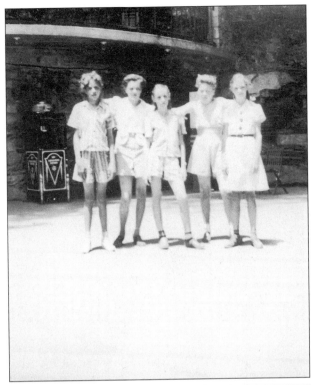

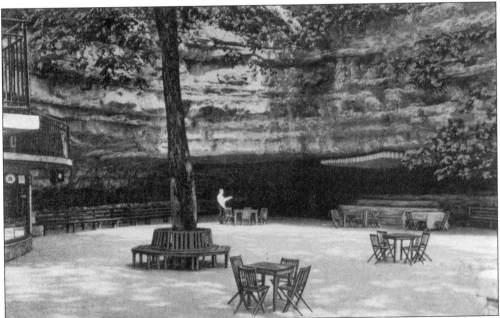

This postcard captures the expansive concrete dance floor and entrance to Dunbar Cave. Big band groups and performers such as Tommy Dorsey, Glenn Miller, and Benny Goodman were regular attractions during the 1930s. Entertainer Roy Acuff purchased the Dunbar Cave area in 1948. He built the present golf course and began featuring country music and square dancing. (TSLA.)

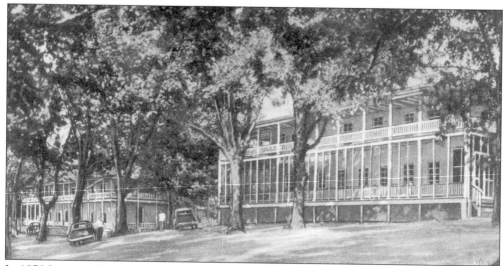

In 1879 James A. Tate purchased property in the Idaho Springs area with the intent of building a hotel. Natural mineral springs are located near Dunbar Cave, and bathing in the springs became the major attraction at the hotel. In 1884 Colonel A.G. Goodlett and H.C. Merritt bought the original hotel and enlarged it. In 1893 the hotel burned and was rebuilt. In the early part of the 1900s, the hotel closed due to lack of interest in the mineral springs. In the 1930s, the hotel was remodeled and reopened. Sadly, the hotel was destroyed by fire again in 1950 and was not rebuilt. (TSLA.)

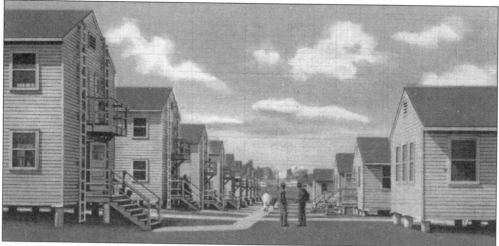

With the advent of World War II, a group of influential citizens began to lobby the United States Army to consider Clarksville for a possible military post. The project became a definite plan after the bombing of Pearl Harbor on December 7, 1941. Over 42,841 acres of land in Montgomery County were acquired for the military post. Initial controversy involved arguments over the name of the camp. William Bowen Campbell had fought the Creek Indians and was an officer in the Mexican War. Then there was the change in designation from Camp Campbell, Tennessee, to Camp Campbell, Kentucky. Over two-thirds of the military post was located in Tennessee, but in September 1942, the designation was changed because of the influence of Senator Alben Barkley of Kentucky. The best explanation was that the post office was located on the Kentucky side. Known today as Fort Campbell, the military base plays a large role in the lives of many Clarksvillians.

Three

DISASTERS

MOTHER NATURE STRIKES CLARKSVILLE

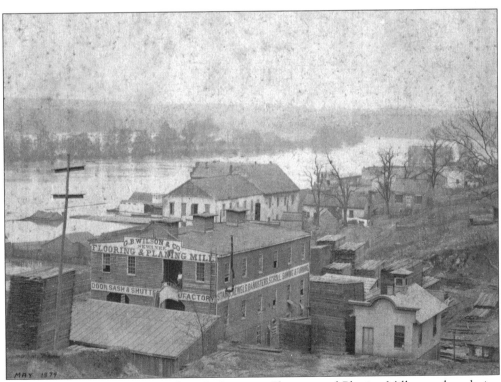

This photograph of the G.B. Wilson & Company Flooring and Planing Mill was taken during the Flood of 1874. The building was located near the Cumberland River at the foot of Commerce Street. (MB.)

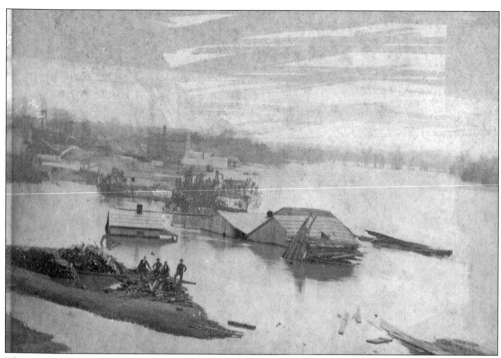

These two photographs of Clarksville were also taken during a flood that struck the area in May 1874. (MB.)

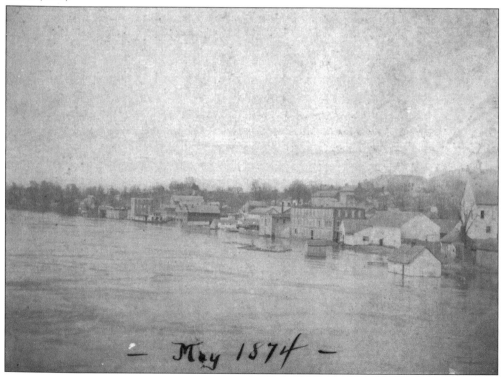

— May 1874 —

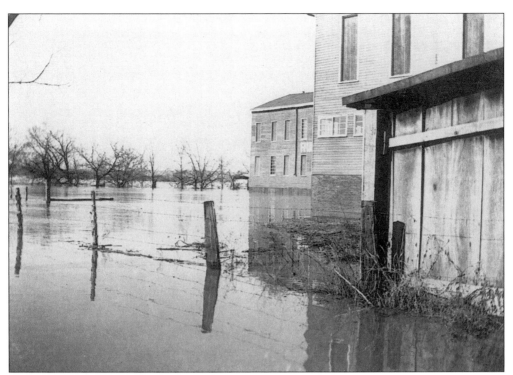

The Flood of 1927 occurred during the month of December. The Cumberland River reached a high of 59.9 feet on January 1, 1928, before it began receding. (MB.)

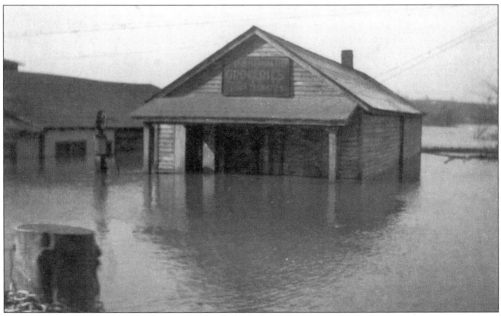

The Sheppard Grocery Store is seen here during the Flood of 1927. Located on Front Street, the store was owned by Mr. Patty Sheppard. (MB.)

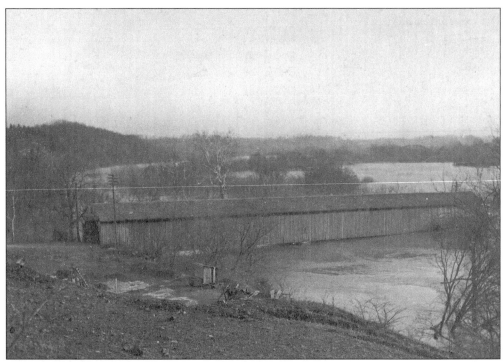

This covered bridge, built in 1854, spanned the lower Red River and connected Clarksville with the New Providence community. In 1927 the flood waters were so high that they met the base of this bridge. (AP.)

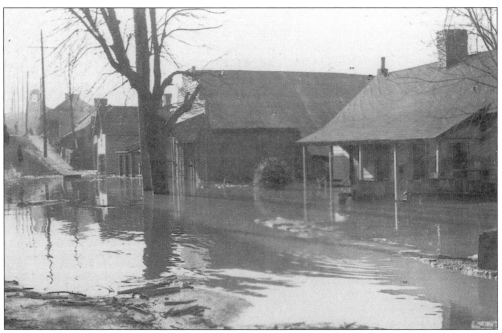

The Flood of 1927 devastated many property owners in the Clarksville area. These homes were located on Spring Street. (MB.)

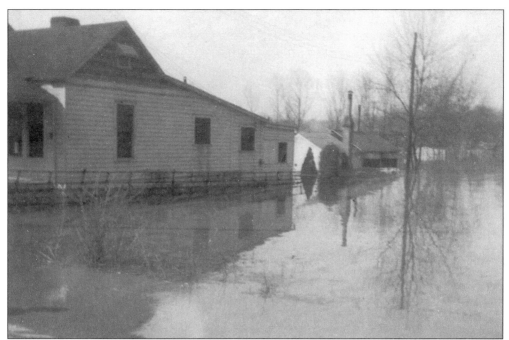

The Flood of 1937 had long and devastating effects upon the people of Clarksville. Heavy rains began in late December 1936, and by Monday, January 24, 1937, the Cumberland River reached an all-time high of 65.5 feet. This photograph shows the intersection of Front and Thomas Streets. (MB.)

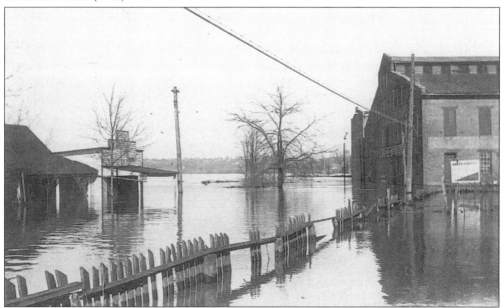

The Elephant Tobacco Warehouse is visible on the right of this photograph taken at the corner of Front and Commerce Streets. The Lewis Grocery is located on the left. Because the city's waterworks was flooded, water for drinking and cooking was very scarce during the Flood of 1937. Every available container was filled with drinking water; some people even used their bathtubs. (MB.)

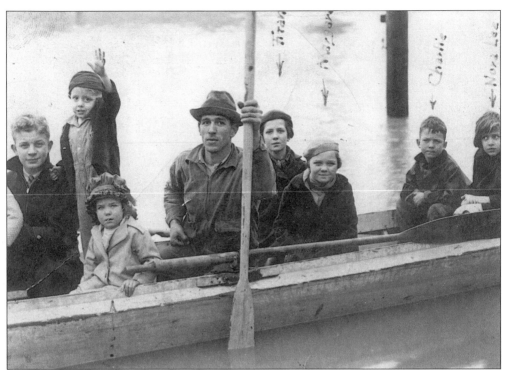

Many people were displaced by the Flood of 1937. The individuals in the boat are, from left to right, unidentified, Johnny Wilyard, Ella Mae Sheppard Bellamy, Newell Wilyard, Francis Sheppard, Margaret Sheppard Nunley, Charles Sheppard, and Nora Lee Wilyard. The Red Cross, the Howell Water Company of Nashville, and the Tennessee National Guard were among the many organizations that offered aid to the people of Clarksville. (Courtesy of Mrs. Ira Nunley.)

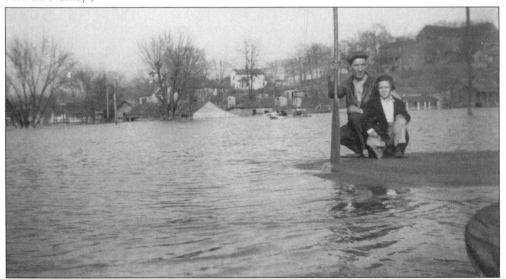

Joseph Moran, a local businessman known to be able to fix virtually anything, and his daughter Mary Jo are pictured here. The two traveled by boat, which was one of few means of transportation available during the Flood of 1937. (Courtesy of Mrs. Mary Jo Dozier.)

The Shell Oil Company was located on Franklin Street, just below the Tennessee Central Railroad office. For many local businesses, the cleanup process after the recession of the floodwaters was very tedious. According to figures from the Tennessee Public Works Administration, losses in Clarksville totaled more than $1 million. (MB.)

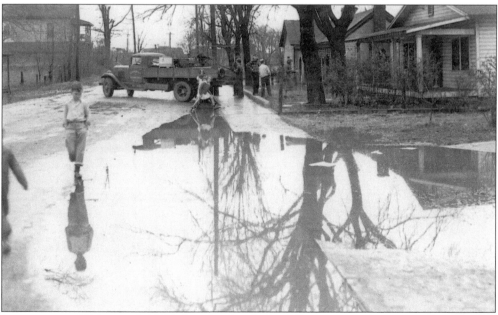

It was not until February 9, 1937, that the Cumberland River returned to a normal water level of 34.9 feet. Here, the receding waters are shown on Front Street near the waterworks. The flood stalled operations at the plant for two weeks. (MB.)

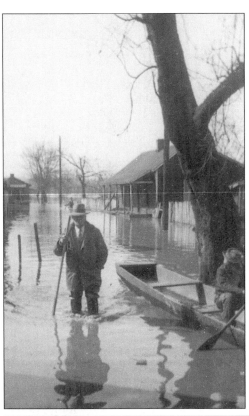

An area at the end of Jefferson Street known as Bogart's Alley did not escape the waters of the Flood of 1937. (MB.)

The receding waters of the Cumberland River are seen in this photograph taken in early February 1937 at Bogart's Alley. (MB.)

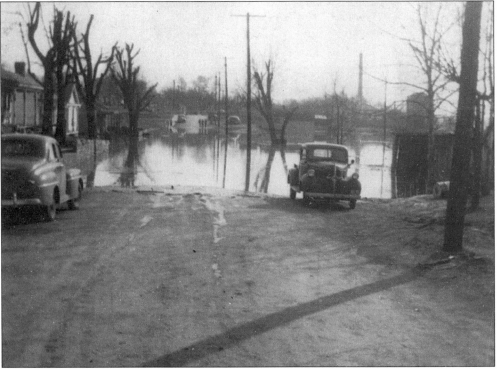

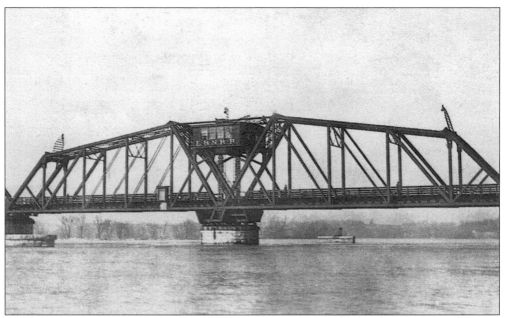

The Louisville and Nashville Railroad (L&N) turnbridge over the Cumberland River serves as a point of reference for the high floodwaters of 1937. In many places throughout the city, the L&N Railroad tracks were washed away. (AP.)

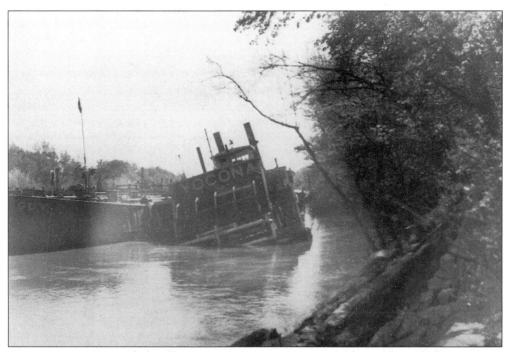

From time to time, Clarksvillians were witness to river accidents. On April 6, 1938, a boat known as the *Yocona* grazed the rock ledge of the riverbank and sank some 15 minutes later. (MB.)

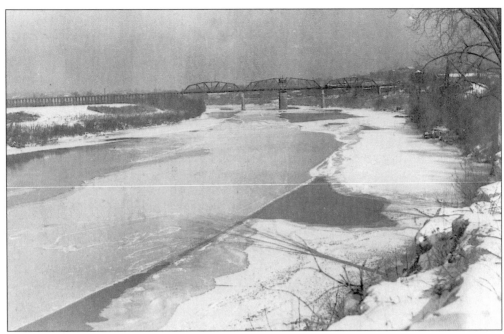

During the winter of 1940, temperatures dropped so low for such a long period of time that the Cumberland River froze over. The ice on the river became so thick that automobiles could successfully cross the river. (MB.)

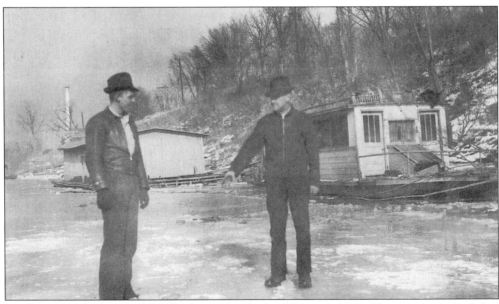

Two men are seen standing on the frozen Cumberland River in 1940. The person on the left is "Punch" Aggett; the person on the right is unidentified. (MB.)

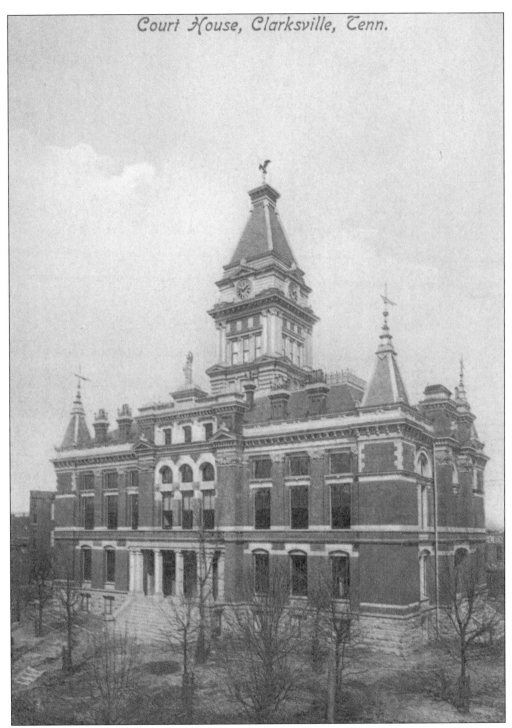

Court House, Clarksville, Tenn.

Long considered to be one of Clarkville's most beautiful buildings, the Montgomery County Courthouse is located on Commerce Street between Second and Third Streets. The present courthouse is Montgomery County's fourth. The first two were located in places that were inconvenient to the public, and the third was completely destroyed by the Great Fire of 1878.

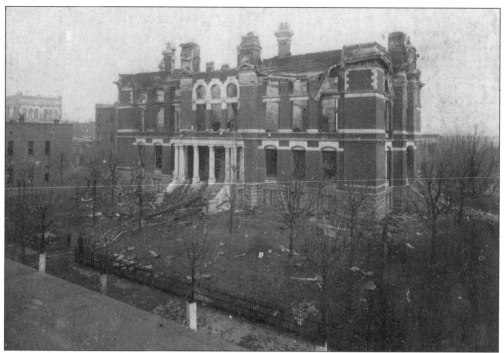

On March, 12, 1900, the Montgomery County Courthouse caught fire. Though the building was not completely damaged, much of the building's interior, as well as the clock tower and the roof, was destroyed. Fortunately, the structure was soon rebuilt. (MB.)

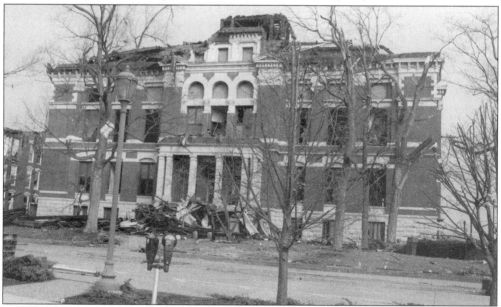

Around 4 a.m. in the morning on January 22, 1999, a tornado struck downtown Clarksville. The Montgomery County Courthouse was among the many buildings damaged in the tornado, and its disastrous appearance symbolized to many what had happened to one of Clarksville's most historic areas. As this book was going to press, plans were being made to restore the courthouse to its former glory. (JH.)

Four

BUSINESSES

COMMERCE IN CLARKSVILLE

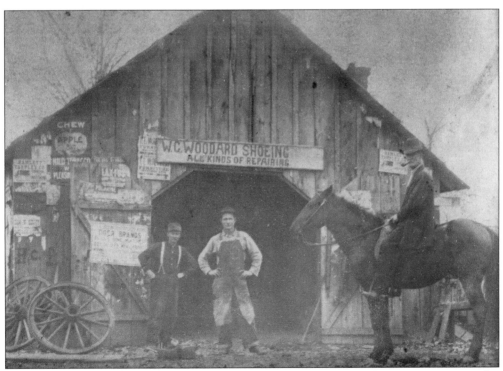

The W.C. Woodward Blacksmith Shop was located in the St. Bethlehem community. This photograph was taken in 1902. (TSLA.)

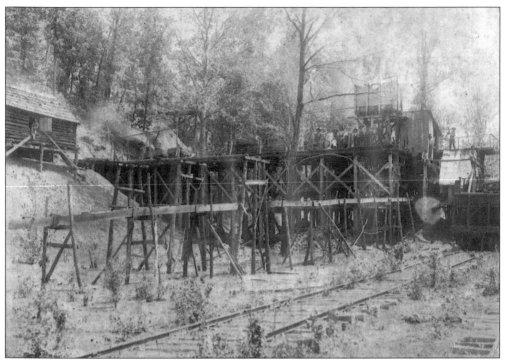

Located off Louise Road in rural Montgomery County in the early 1900s, the Warner Iron Ore Company was managed by Elijah Murphy, whose descendants still live in the area. This photograph shows the washer, where the ore was rinsed before being smelted. (RR.)

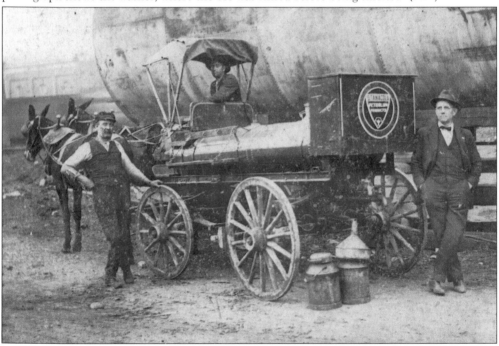

In this late 1800s photograph, a Standard Oil Company truck makes fuel deliveries in the Clarksville area. (MB.)

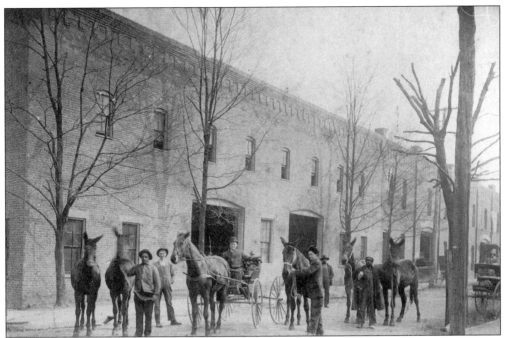

This sales stable was located at Main and Third Streets. W.A. McCraw was the owner of the stable, and he is pictured in the buggy with his horse, Lady, in this photograph taken in 1912 or 1913. (TSLA.)

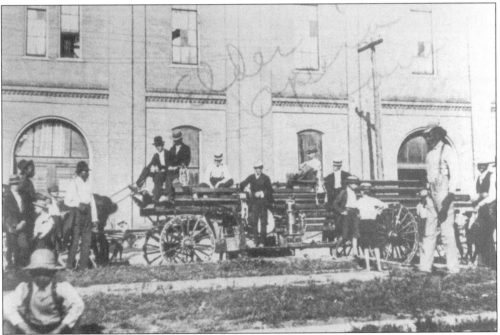

The Clarksville Fire Department tests hook and ladder equipment in front of Elder's Opera House in 1910. Located at the corner of Franklin Street and Public Square, Elder's was a place where many musical and theatrical performances took place. Sadly, Elder's Opera House burned to the ground in the December 1914 fire. (MB.)

This scenic view of the intersection of Main and North Second Streets shows Ladd's Service Station in the foreground and Mrs. Wiggins's Boarding House in the background. Mrs. Wiggins's Boarding House was the original home of J.E. Elder, the first mayor of Clarksville. (TSLA.)

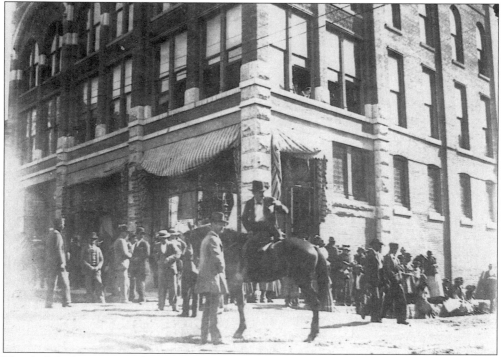

The A.C.O. Drug Store, whose name stood for Askew, Coulter, and Owen, was located on the corner of Franklin and Second Streets, across the street from the Northern Bank. The soda fountain is still remembered as a very popular gathering place for young people. (MB.)

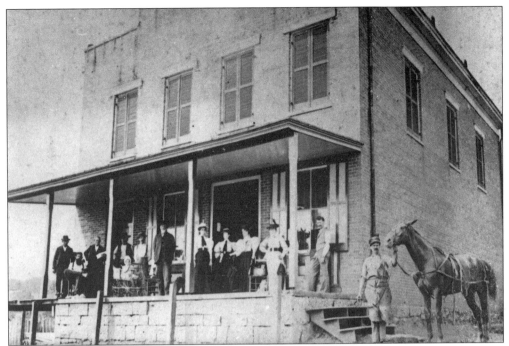

This photograph of the Port Royal General Store was taken in 1895. This structure still stands today. (TSLA.)

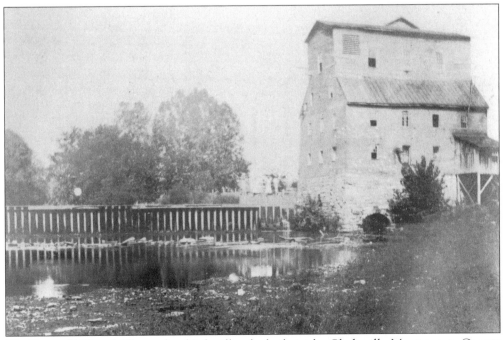

The Ringgold Flour Mill was the third mill to be built in the Clarksville-Montgomery County area. It was turbine powered and could grind 60,000 bushels of wheat in a year. Stone masons from Ireland designed the mill's dam in the late 1850s. The mill ceased production in 1971, but it is still maintained today by R.E. Durrett Jr., a descendant of the original owners. (TSLA.)

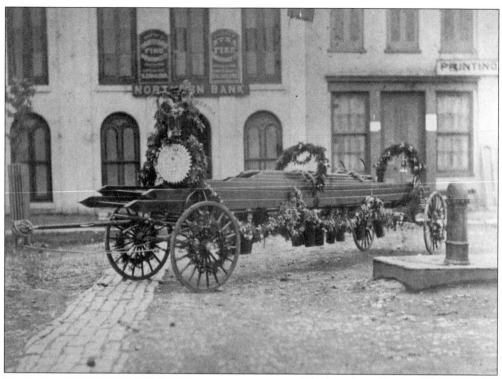

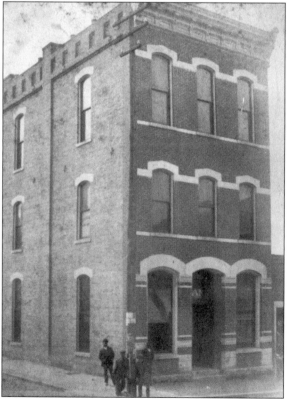

The Northern Bank of Tennessee, the first state bank in Clarksville, was founded in 1854. Because of the foresight of its owners, Northern Bank was one of the few banks to withstand the Civil War. All assets were transferred to European banks. Until a merger in the 1980s, it was one of two banks in the South to still conduct business under its original name and charter. This photograph shows the original location of the bank on Public Square. A Clarksville Fire Department ladder wagon is decorated in front of the bank in this 1878 photograph. (TSLA.)

This 1888 photograph shows the Northern Bank of Tennessee at its location on the corner of Franklin and North Second Streets. Northern Bank was located in this building from 1885 to 1957. This structure was damaged in the 1999 tornado and was later razed. (TSLA.)

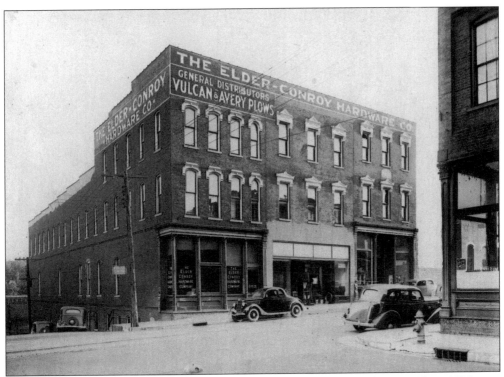

The Elder-Conroy Hardware Company, which conducted business from 1865 to 1980, was located on Franklin Street at Public Square. The advertisement on the side of the building is still visible today. (AP.)

John Rabbeth and Joseph Dunlop founded the Rabbeth & Dunlop Milling Company in 1893. The two men constructed a large mill on property at the east end of Franklin Street. The original mill burned in 1895 but was rebuilt. This postcard features the second mill that was constructed on the property. In 1911 the partnership between Rabbeth and Dunlop was dissolved, resulting in a change of the mill's name to simply Dunlop Milling Company.

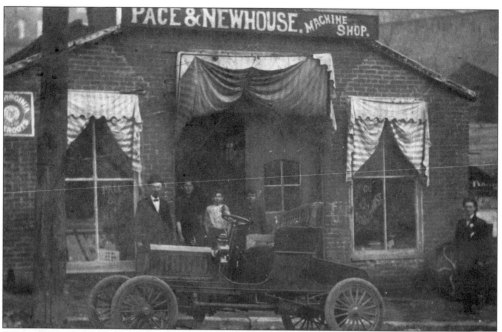

The Pace and Newhouse Machine Shop was owned by Spencer Newhouse and was located on South First Street behind what is now the Roxy Theatre.

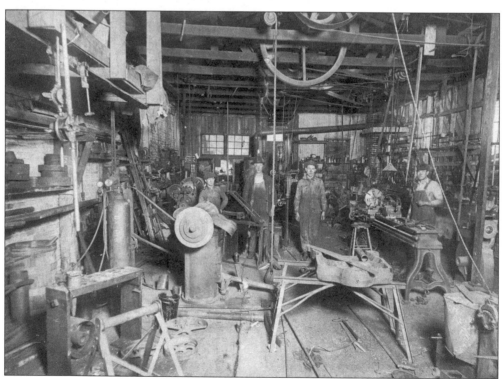

The Pace and Newhouse Machine Shop had machinery and equipment scattered throughout the building.

This photograph was also taken inside the Pace and Newhouse Machine Shop.

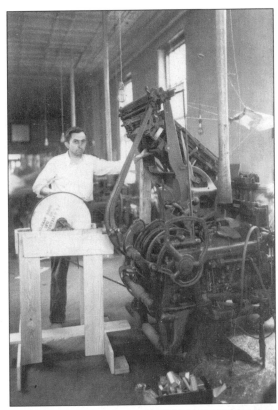

The W.H. Rudolph and Company building was located on Public Square across the street from the Poston Buildings. The site is currently occupied by the parking lot of the First Union Bank. (MB.)

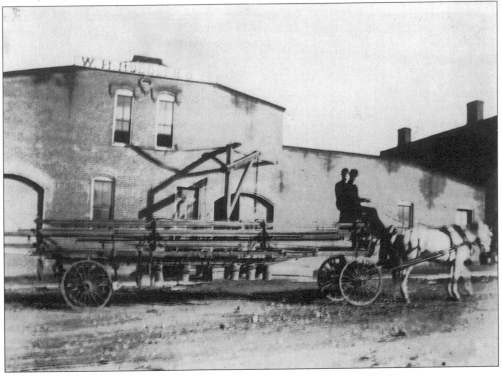

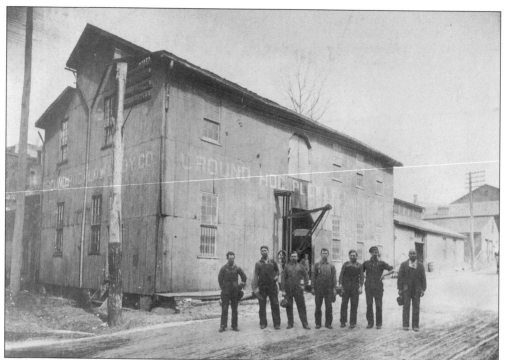

The Drane Foundry and Supply Company is pictured here in 1914 at its Commerce Street location. (TSLA.)

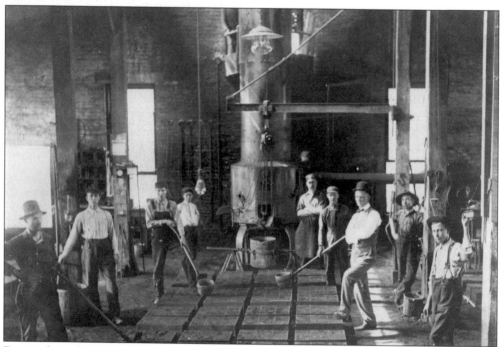

During the early 1900s, C.H. Drane acted as the president and general manager, William Drane acted as the vice president, and P.A. Rodriguez acted as the secretary-treasurer of the Drane Foundry and Supply Company. (TSLA.)

The Joseph Moran Welding and Machine Shop was founded in 1925. In this 1954 photograph, the company's building at 119 North First Street is undergoing renovation.

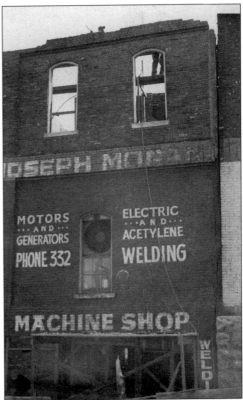

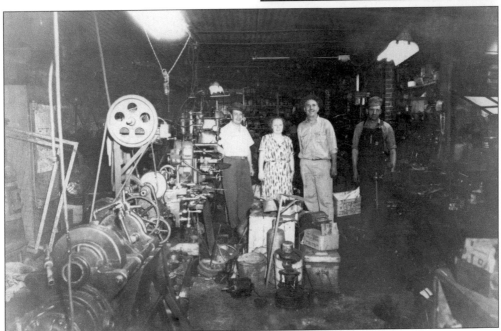

From left to right, Mr. Ernie Oblander, Mrs. Nancy Moran, Mr. Joe Moran, and Mr. Richard Patterson pose inside the Joseph Moran Welding and Machine Shop. The shop's motto was "We Can Fix It."

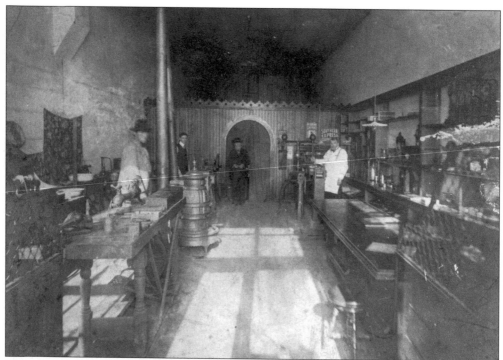

This photograph of A.J. Clark Jewelers is believed to have been taken during the 1890s. On the right is Mr. A.J. Clark. This store was located in the 200 block of Franklin Street. (TSLA.)

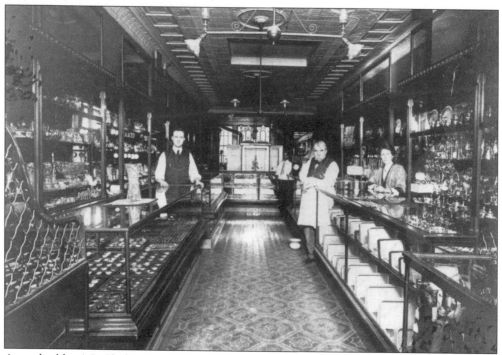

A much older A.J. Clark is seen on the right, along with his wife, in this 1915 photograph. A.J. Clark Jewelers moved to this location at 131 Franklin Street in 1902. (TSLA.)

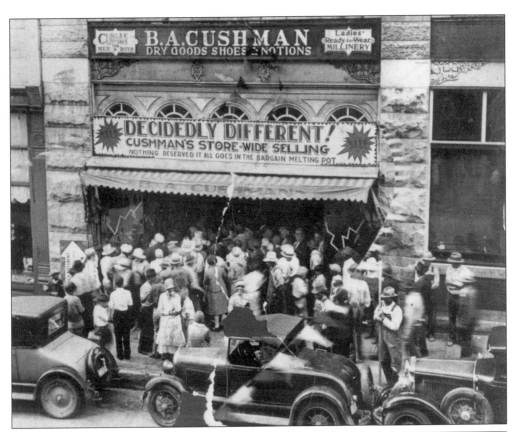

The B.A. Cushman store, a general merchandise store, was located on Franklin Street. (TSLA.)

Frank Fiederling's cigar and tobacco business, located on Franklin Street, won the admiration of a number of children because of its life-sized wooden Indian, which stood outside the store with raised tomahawk in hand. Mr. Fiederling purchased the Indian in 1883 at the discounted price of $45. (AP.)

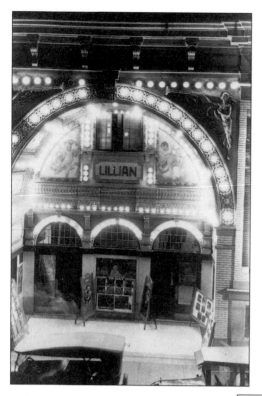

The Lillian Theatre was located on the corner of Franklin and First Streets, the present site of the Roxy Theatre. It opened in 1913 and was named after the daughter of the owner, Joseph Goldberg. Sadly, the original theatre was severely damaged in the 1914 fire but reopened in 1915. In 1941, the Lillian was renovated and became the Roxy. In 1945 the first Roxy burned but reopened in 1947.

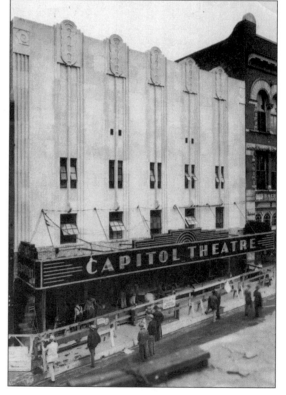

The original Capitol Theatre was built in 1928 and located on Franklin Street. It burned in 1935, and a new Capitol Theatre, seen here, was built across the street and opened in 1936. The Clarksville Transit System transfer station now occupies the site of the second Capitol Theatre. (MB.)

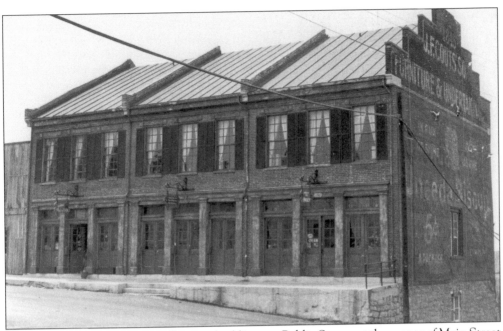

John H. Poston built this row of historic buildings on Public Square at the corner of Main Street in 1843. Poston moved to Clarksville at the age of 19 and became a leader in the community, serving as mayor in 1830. Poston gave the block of buildings to his daughter and son-in-law, Adeline and J.F. Couts, as a wedding present. The Poston Buildings originally housed a clothing store, an unsuccessful grocery store, and later a successful furniture store and undertaking business. (LOC.)

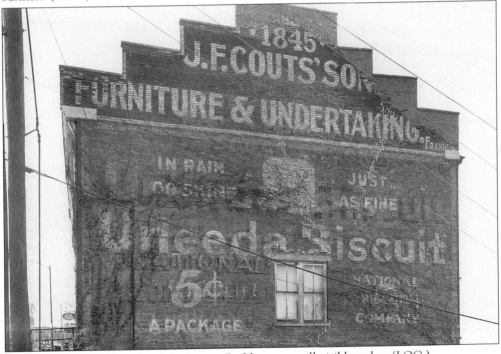

Advertisements on the side of the Poston Buildings are still visible today. (LOC.)

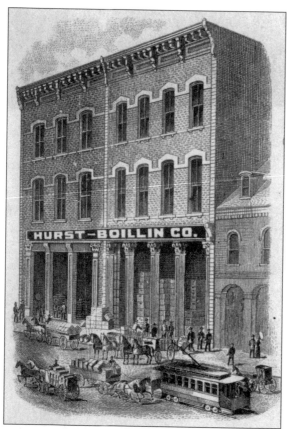

This drawing was taken from a 1915 billhead of a local wholesale grocer, the Hurst-Boillin Company. John Hurst, the president of the company, was a Civil War veteran and father-in-law to Governor Austin Peay. This structure was known to many as the Boillin-Harrison Building and was located on Franklin Street at Public Square. Recently razed, the building was historically significant because of its connection to Clarence Saunders. Saunders spent some of his early years in the Clarksville area working in the grocery business before he moved to Memphis and founded Piggly Wiggly, the first ever self-service grocery store.

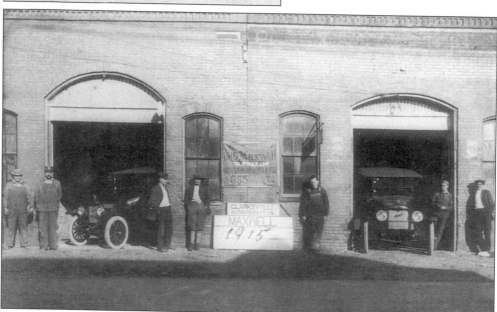

The Maxwell Auto Agency and Repair Company was located on Commerce Street. Pictured in this 1915 photograph are, from left to right, unidentified, W.E. Bard, R.E. Coots, Alex Chandle, Walter Gaise, M.W. Quarles, and E. Sanders. (MB.)

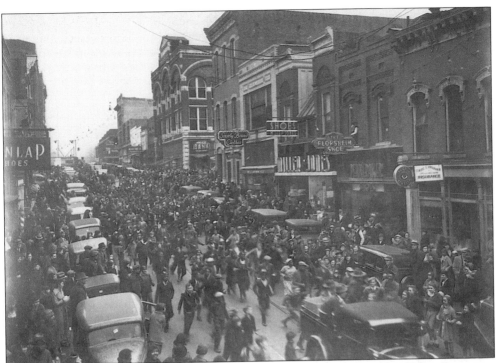

A very crowded Christmas Parade during the 1930s takes place on Franklin Street. Businesses with Christmas decorations are visible in this photograph. (MB.)

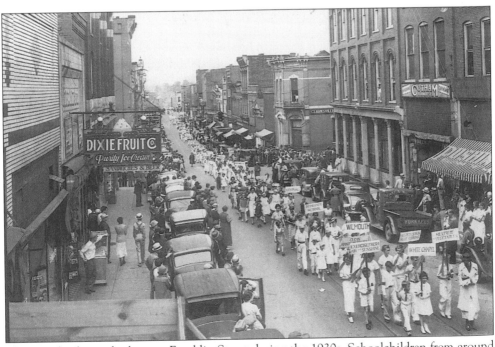

This parade also took place on Franklin Street during the 1930s. Schoolchildren from around Montgomery County were marching to increase health awareness. The children carried placards with their school names visible for all to see. (MB.)

This photograph of the Goldberg Furniture Company was taken from a postcard that was mailed to area residents in 1948 announcing the store's first anniversary sale. The store was located on Franklin Street.

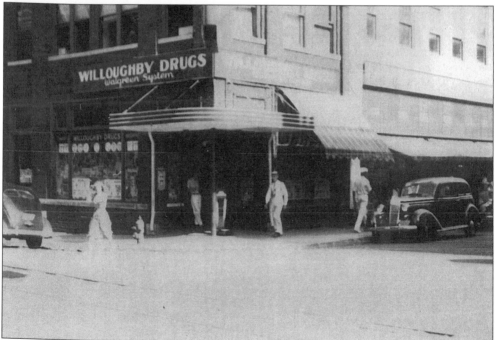

The Willoughby Drugstore was located on the corner of Third and Franklin Streets. (RR.)

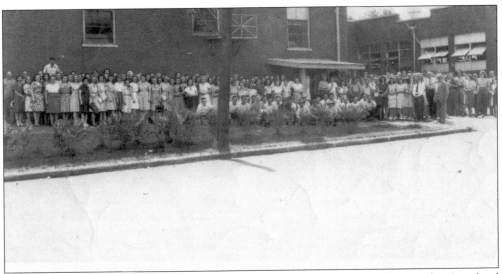

This photograph of the employees of the Acme Boot Company was taken at the Crossland Avenue factory in 1937. The company began production in the building, a converted hosiery mill, some eight years earlier as the Acme Shoe Manufacturing Company. In 1935 the company began manufacturing boots and soon became the largest boot maker in the world. (RR.)

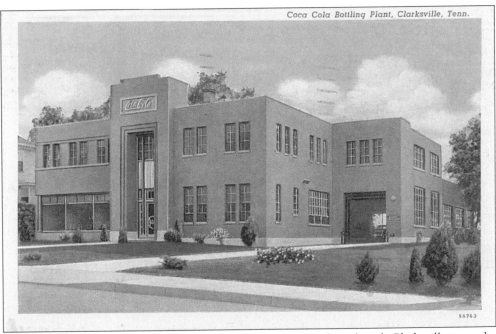

Coca Cola Bottling Plant, Clarksville, Tenn.

One of the first industrial companies to come to agriculture-based Clarksville was the Coca-Cola Bottling Company. The original plant, which began operation in 1906, burned to the ground in 1914. Later, the bottling plant seen here opened on North Second Street.

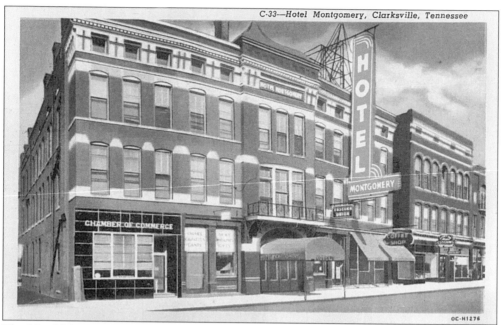

The Hotel Montgomery was originally known as the Arlington Hotel and was located on the corner of Second and Commerce Streets.

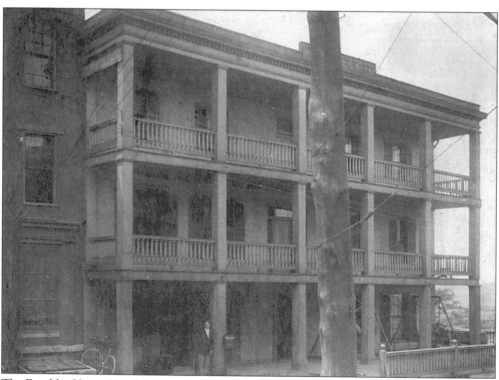

The Franklin House Hotel dates to the 1850s. The structure, which burned in 1946, was located on Franklin Street near Public Square. For much of its existence, it was considered one of the finest hotels in Clarksville. (AP.)

Built in 1947, the seven-story Royal York building is situated at the corner of Third and Madison Streets. One of the tallest structures in Clarksville and once one of the city's most modern hotels, it has since been converted into apartments.

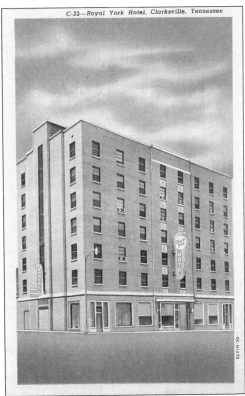

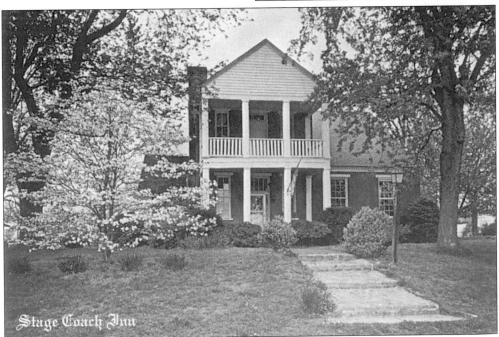

The Stage Coach Inn became a private residence in 1976. It is located in Kentucky just across the Tennessee border on Guthrie Highway. It was built in 1833 as the Graysville Inn by Major John Gray.

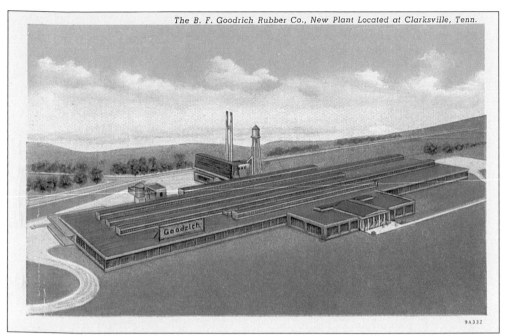

The B. F. Goodrich Rubber Co., New Plant Located at Clarksville, Tenn.

9A332

The B.F. Goodrich Rubber Company plant, seen here in two postcard images, began production in Clarksville in 1939. In 1972 the facility was sold to the Vulcan Corporation. It is still in operation today.

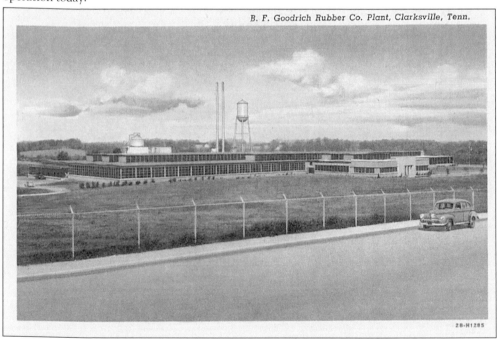

B. F. Goodrich Rubber Co. Plant, Clarksville, Tenn.

2B-H1285

Five

HOMES AND CHURCHES

CLARKSVILLE'S FOUNDATIONS

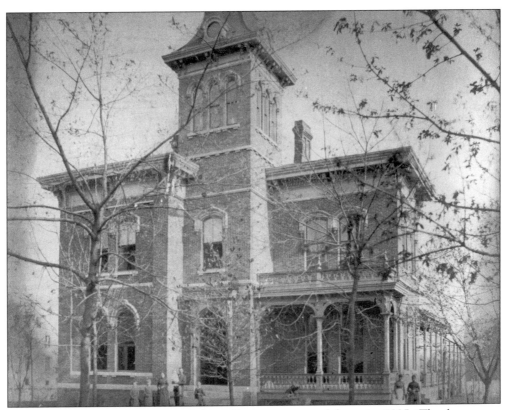

The Edmondson residence on Madison Street is pictured here in 1885. The home was once used as the Clarksville Hospital before the hospital moved to a more permanent location on North Second Street. At one point, this beautiful Italianate home housed First American Bank. (TSLA.)

The J.B. Coulter home on Mumford Avenue is pictured here in 1890. The residence was designed in the Victorian clapboard style. (TSLA.)

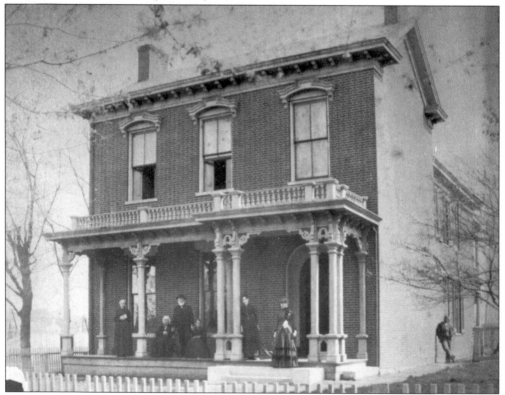

S.B. Sears, pictured here with his family at their home on Madison Street, was a Baptist minister. This photograph was taken in 1885. (TSLA.)

The Presbyterians were the first church group to formally organize in Clarksville. Their original structure was built in 1839–1840 at the same location as the present church, which is featured here. Mrs. Lucinda Elder donated the lot for the sanctuary. The current church was built and ready for use in May 1878. Construction costs totaled $43,000, but amazingly the entire debt was paid before the church was formally dedicated. The steeple on the left was remodeled in the 1930s. (TSLA.)

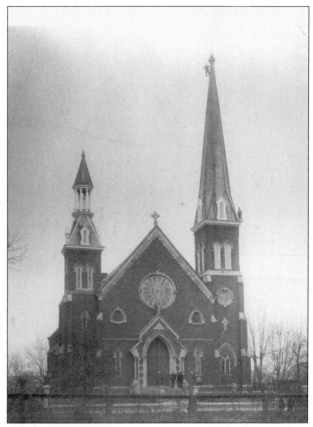

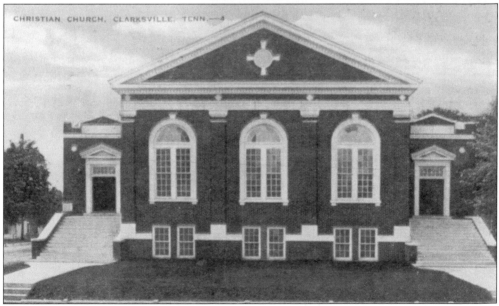

Members of the First Christian Church constructed and opened their first sanctuary on the corner of Madison and Third Streets in 1849. This postcard depicts the present church at 516 Madison Street. (TSLA.)

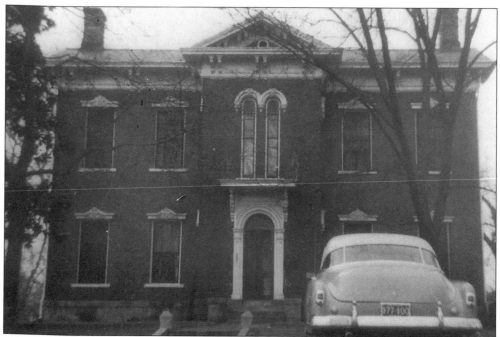

This photograph of the Catlett House on Home Avenue was taken in 1957. The home, which was a beautiful and historic structure, was later torn down. (Courtesy of Mrs. Doris Rittenberry.)

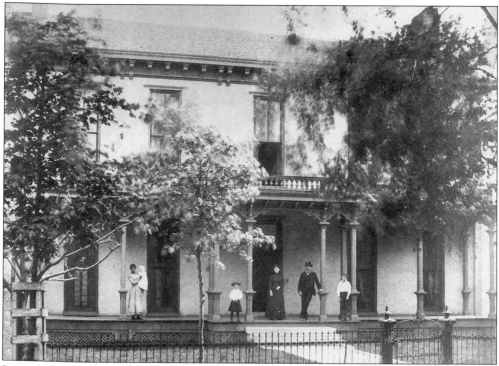

James Smith served as mayor of Clarksville in the late 1880s. Here he is pictured with his family at their residence on Madison Street. (TSLA.)

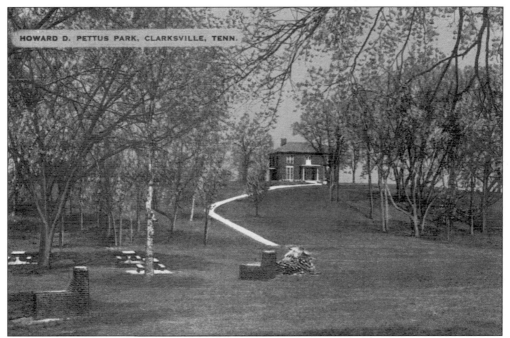

Howard D. Pettus Park was named in honor of the local philanthropist who dedicated himself to the betterment of the community. Austin Peay State University (APSU) acquired Pettus Park from local officials in 1967, and in 1974 construction of the Dunn Center began on the site.

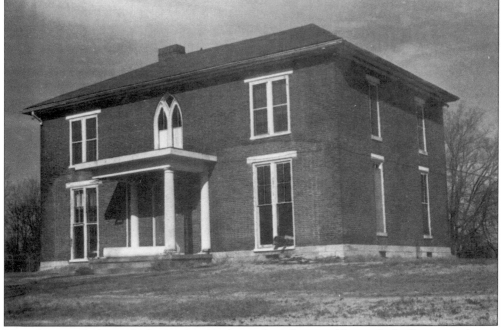

This photograph shows the house that was located on the site of Pettus Park. Constructed prior to the Civil War, it was known as the Humphries House. (AP.)

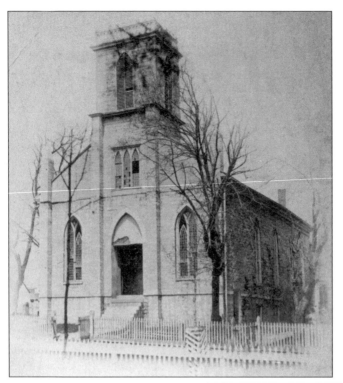

The congregation of Trinity Episcopal Church was organized in 1832. They started construction of their original church in 1834 and consecrated the building in 1838. It was located on Franklin Street. (TSLA.)

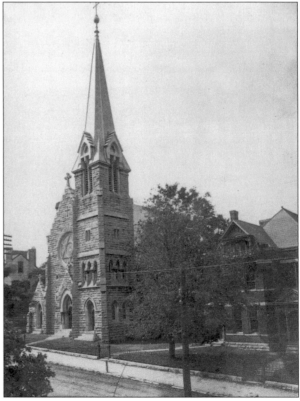

Construction of the present Trinity Episcopal Church began in 1875 and was completed in 1881. The church's beautiful pipe organ was on display in Philadelphia in 1876. The church was hard hit by the 1999 tornado, but many repairs have taken place including the replacement of the structure's steeple. (AP.)

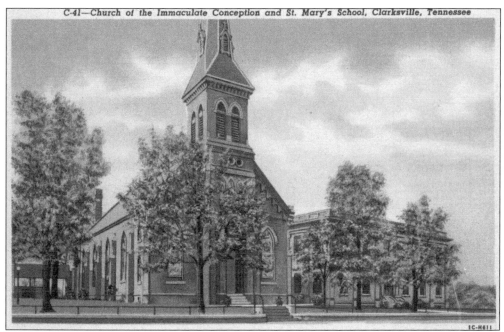

Immaculate Conception Catholic Church is located on the corner of Franklin and North Seventh Streets. This structure was built in 1880 under the direction of Father Patrick Gleeson and replaced an older sanctuary on Washington Street. The bell in the tower was brought to Clarksville from Ireland. St. Mary's School educated hundreds of children in Clarksville and had its beginnings in the early 1900s under Father James A. Nolan. The school closed in the 1970s due to low enrollment

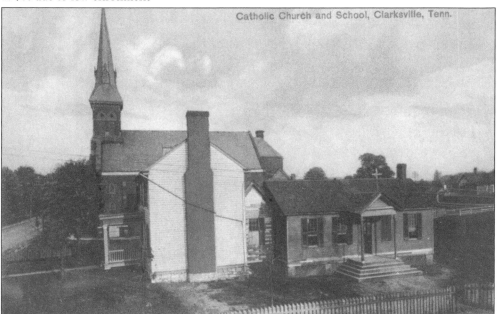

Catholic Church and School, Clarksville, Tenn.

The original St. Mary's School building of the Immaculate Conception Catholic Church is visible in the foreground of this postcard. A new St. Mary's School opened in August 2000 on Madison Street.

First Baptist Church on Madison Street is depicted in this postcard. The building was constructed in 1917. Still in use today, it is the third church building for Baptists in Clarksville.

The Methodists were the first congregation to build a church in Clarksville. The original church, built in 1831, is used today as a residence. This photograph shows the church's later location near the intersection of Madison and Third Streets. Notice the many trees that once lined Madison Street. (TSLA.)

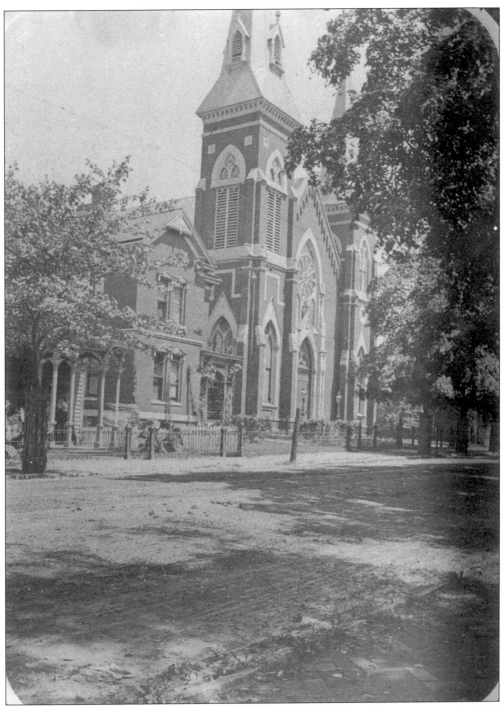

Sadly, the Madison Street Methodist Church was one of the hardest hit structures in the 1999 tornado. The two steeples, a large stained-glass window adorning the front facade, and an ornate pipe organ were some of the church's most beautiful features. (TSLA.)

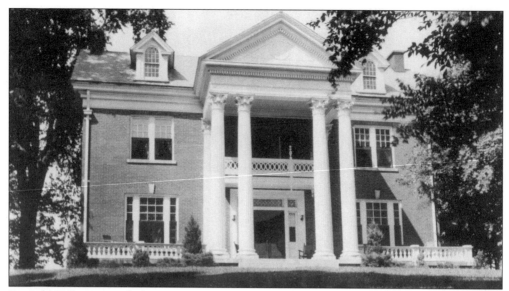

Emerald Hill is a stately home on North Second Street that is currently used by the alumni association and alumni relations of Austin Peay State University. In 1965 Patrick Henry Cross willed his home and estate to APSU. The home was not formally used by the university until 1974, when Emerald Hill was restored. The home was once owned by Gustavus A. Henry, a Tennessee statesman and leader of the Whig party prior to and during the Civil War. (TSLA.)

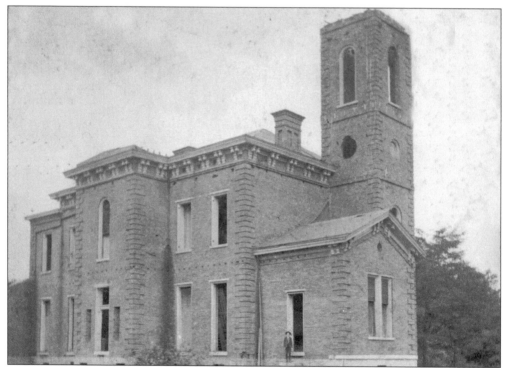

Adolphus Heiman designed this mansion in 1859 for Bryce Stewart, a professor at Stewart College, which later became Southwestern Presbyterian University. It was called Stewart Castle but was never actually completed. (TSLA.)

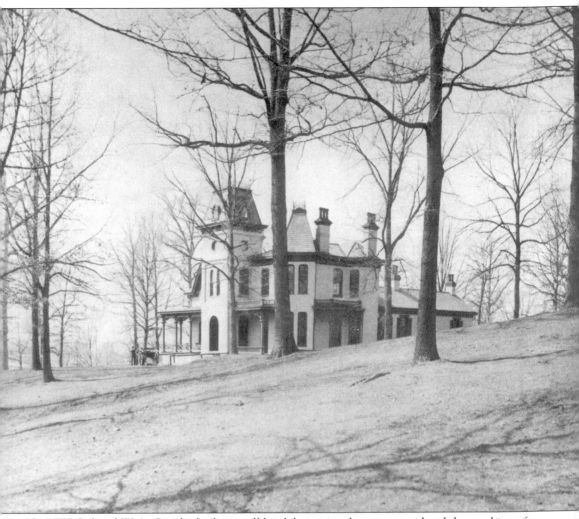

In 1857 Colonel W.A. Quarles built a small brick house in what was considered the outskirts of Clarksville. Very soon after, Quarles left Clarksville to fight in the Civil War, and upon his return, James L. Glenn assumed ownership of the home and surrounding property to pay Quarles's debts. Various members of the Glenn and Childers families maintained the property until 1921, when the property began changing hands among a number of groups. During the Great Depression, it was auctioned off to the Northern Bank of Tennessee. In 1935 Judge W.D. Hudson bought the home and began major renovation work. The present owners are Dr. and Mrs. Steve Wallace, who undertook the third major renovation of the home. (Courtesy of Dr. and Mrs. Steve Wallace.)

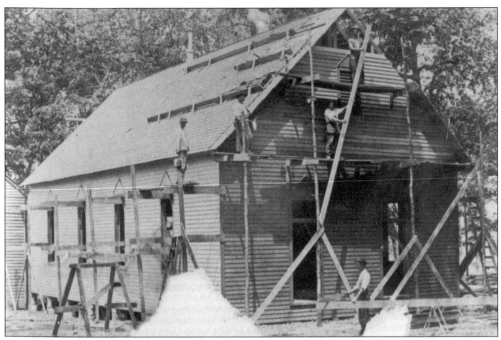

This photograph was taken in 1910 of an unidentified rural Montgomery County church. (TSLA.)

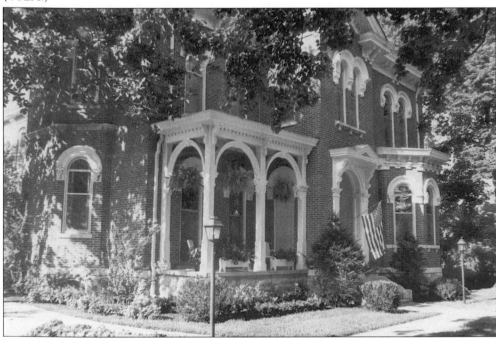

Located on the campus of Austin Peay State University, Archwood was originally built by Samuel Rexinger, Clarksville postmaster from 1867 to 1883. The architectural style is Italianate with beautiful walnut woodworking throughout the interior. In 1965 Archwood was acquired by the State of Tennessee and was used as the APSU president's home. Archwood suffered damage during the 1999 tornado, but it is currently being renovated. (TSLA.)

This photograph of the William C. Smith home in New Providence was taken in 1902. (TSLA.)

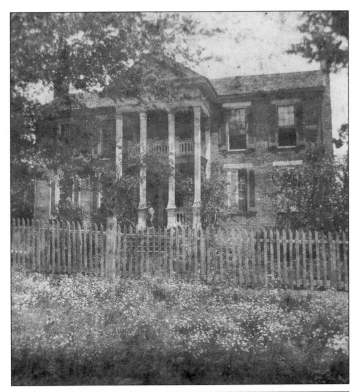

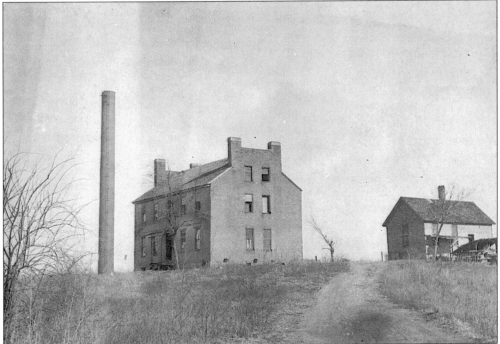

John H. Poston built the first home between the Red and Cumberland Rivers. Pictured here is the third home built on the same site. This house was dismantled in 1940, and the brick was used to construct two smaller homes on McClure Street near First Street. (AP.)

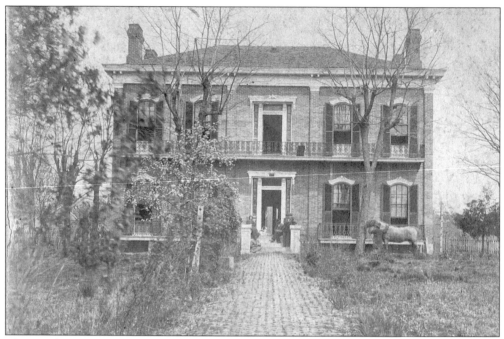

This residence originally served as the country home of John Dicks, an early Clarksville businessman who was helpful in the economic development of the community. It is now known to most citizens as the Dicks-Brown home. (MB.)

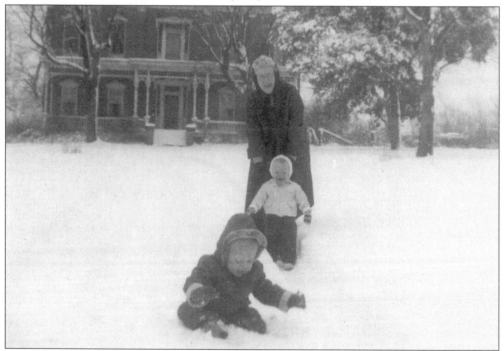

Though it has fallen into disuse, the Dicks-Brown home still stands near Golf Club Lane. This photograph was taken during a large snowstorm in late 1959. (Courtesy of Mrs. Doris Rittenberry.)

Six

SCHOOLS

EDUCATING CLARKSVILLE'S STUDENTS

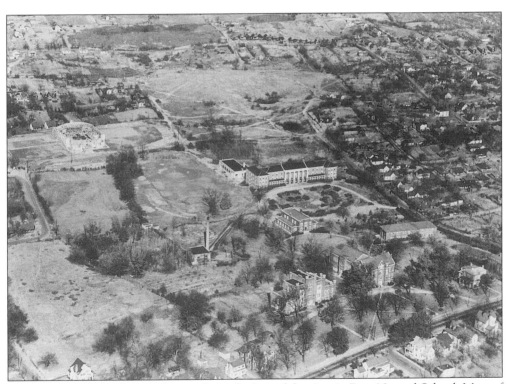

This aerial photograph was taken in the early days of the Austin Peay Normal School. Most of the buildings in the photograph were originally part of the Southwestern Presbyterian University campus. In the middle of the photograph is Harned Hall, a women's dormitory built in 1931. It was one of the few new structures built at the time of this photograph. (TSLA.)

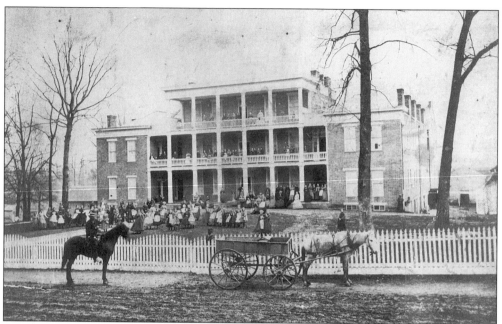

The Clarksville Female Academy was a school that evolved over the years. It was originally called the Female Academy in 1836 and in 1842 was renamed the Masonic Female Institute. Classes were first held at the Masonic Hall and later at the Methodist church property on the corner of Main and Fourth Streets. The school was reorganized as the Clarksville Female Academy in 1846, and they moved classes to a former residence on Madison Street. During the Civil War, the school was used as a hospital. (TSLA.)

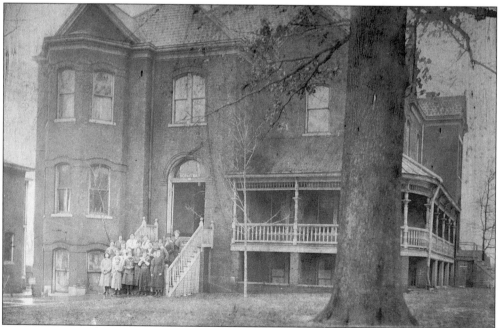

Many students boarded at the Clarksville Female Academy, as the school attracted young ladies from many other communities. This 1918 photograph features the school's dormitory. (TSLA.)

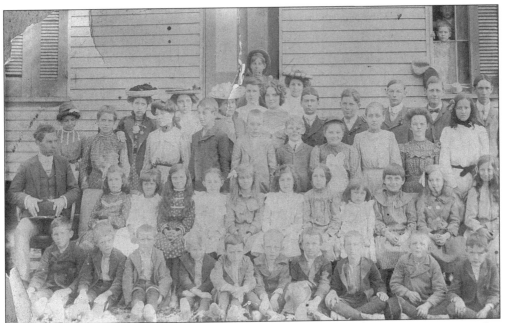

This photograph of the students of St. Bethlehem Central School was taken in November 1902. B.C. Thomason was the teacher. (Courtesy of Mrs. Mary Jo Dozier.)

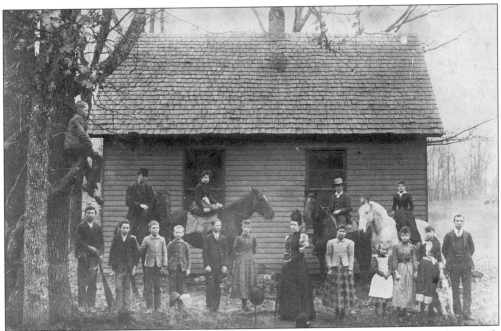

Woodlawn School was located near Port Royal in rural Montgomery County. This photograph was taken in February 1891. Rob Bourne is the student in the tree. Standing in the front are, from left to right, Wade Holt, Frank Rosson, Alva Elliot, William Bourne, Lucian Atkins, Sallie Gaines, Harriet Parks, Nora Holt, Lorene Elliot, Minerva Elliot, Ethel Hamlet, and George Keel. On horseback are, from left to right, Jack Hamlet, Sallie Watson, Leslie Watson, and Mary Keel. Harriet Parks Miller later wrote *The Bell Witch of Tennessee*. (TSLA.)

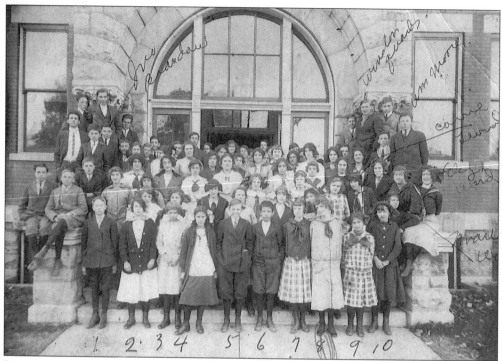

Pictured here is a group of graduating Clarksville High School seniors from the early 1900s. (MB.)

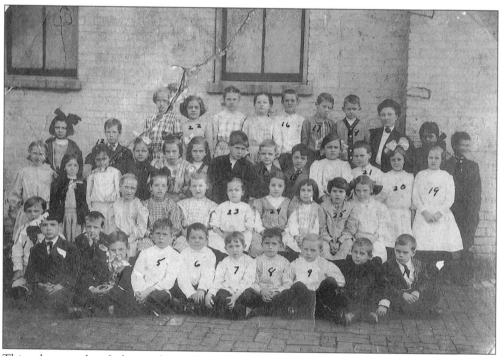

This photograph of the students from the High Street School was taken in the early 1900s. (MB.)

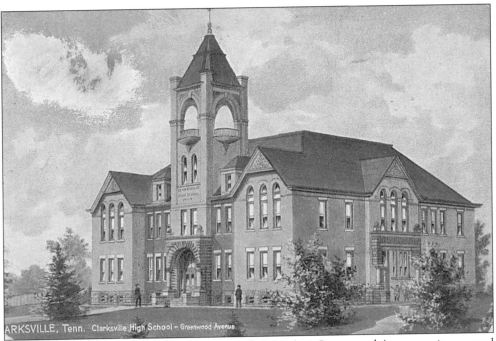

This postcard shows the original Clarksville High School on Greenwood Avenue as it appeared at its opening in 1907. Fire later destroyed the original structure.

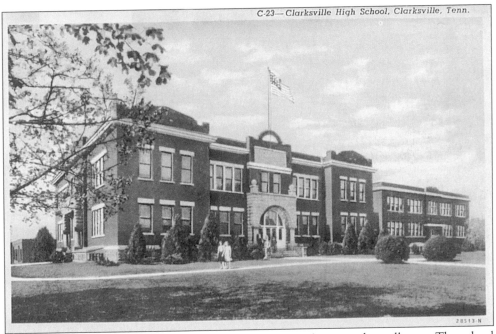

In 1916 Clarksville High School was expanded because of increased enrollment. The school was later moved to a more modern building on Richview Road, with this structure currently being used as apartments. (TSLA.)

99

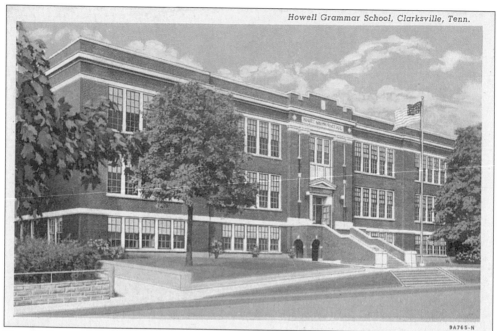

Howell Grammar School was located on Franklin Street. The building served a number of uses, most recently as administrative offices for the Clarksville-Montgomery County School System.

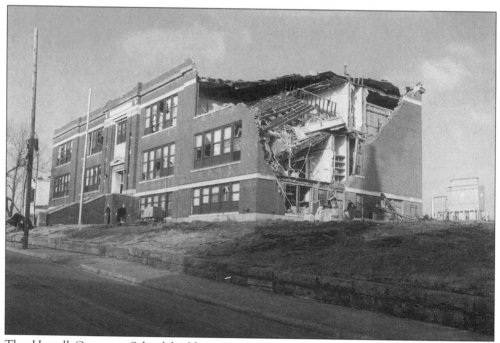

The Howell Grammar School building was severely damaged by the 1999 tornado. Efforts were underway to renovate the structure when it was completely destroyed by fire later in the year. (JH.)

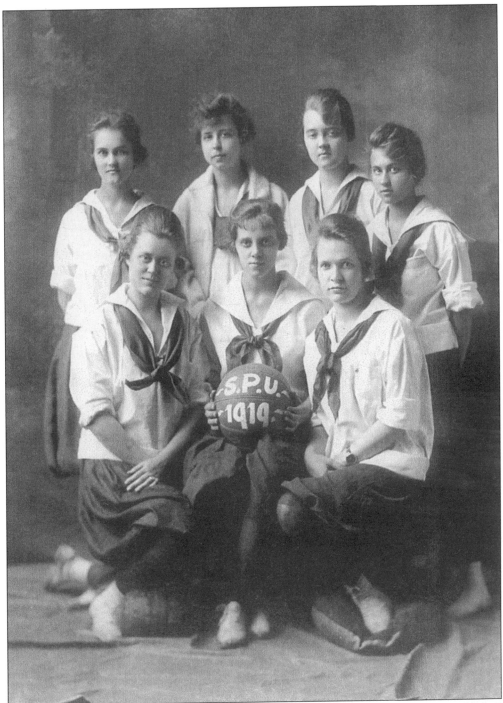

This photograph shows the 1919 Southwestern Presbyterian University women's basketball team. Pictured from left to right are (front row) Louise Perkins Miller, Ursula Smith Beach, and Mildred Smith Glenn; (back row) unidentified, Margaret Trahern Patch, Eleanor Caroland Grizzard, and Katherine York Hunt. Ursula Smith Beach later became the Montgomery County historian. (RC.)

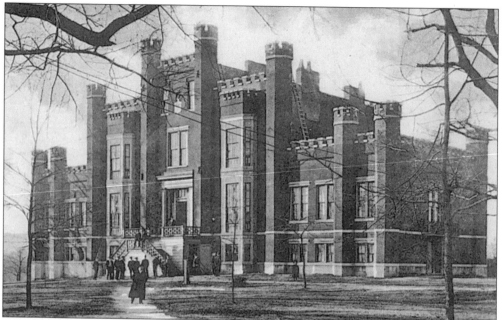

In 1875 Southwestern Presbyterian University was formally established in Clarksville. The school had been in the area since 1825 and was known by the following names: Rural Academy, Mt. Pleasant Academy, Clarksville Academy, Masonic College, and Stewart College. In this photograph is the Castle Building. Built in 1850, it served as the centerpiece of the campus. (AP.)

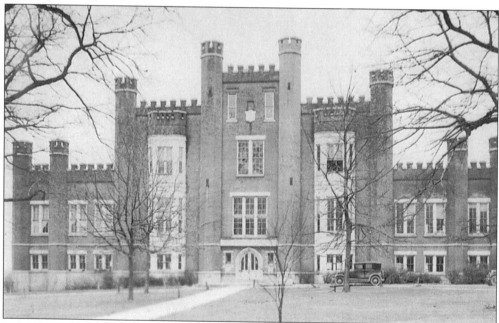

In 1925 SPU relocated to Memphis, Tennessee, and is known today as Rhodes College. The campus was not vacant for long, as Austin Peay Normal School was created in 1927. The Castle Building was among the many structures renovated for the use of the new school. Notice that the steps along the front of the building have been removed. (AP.)

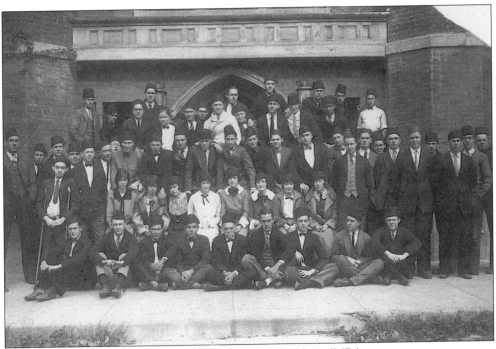

A group of students is pictured in front of the Castle Building. (MB.)

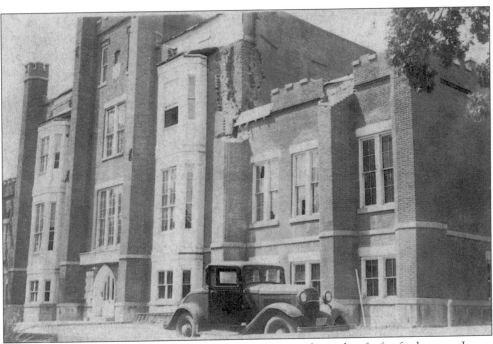

In 1946 part of the Castle Building collapsed, and it was deemed unfit for further use. It was soon razed. (MB.)

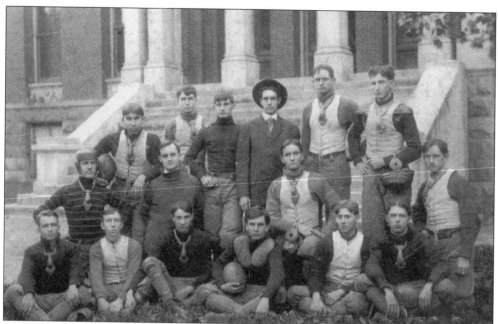

Southwestern Presbyterian University's 1904 football team photograph was taken on the steps of the Montgomery County Courthouse. The members of the team are, from left to right, (front row) John D. Allen, William H. Allen, James D. Rhea, George I. Briggs, Howard Thompson, and Robert S. Lemon; (middle row) Charles E. Allen, John L. McKinstry, John C. Culley, and William K. Harrison; (back row) James B. Guthrie, William McLeod, William H. McIntosh, Charles L. Power–manager, George W. Cheek, and Samuel E. Crosby. (RC.)

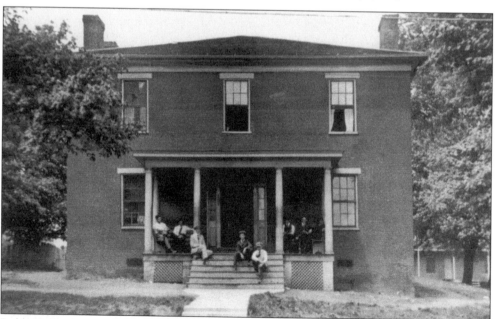

Robb Hall was one of the earliest buildings on the SPU campus. During the Civil War, the Union Army occupied the building. Over the years, it served a number of purposes, including male and female dormitories and apartments. The building was razed in 1967.

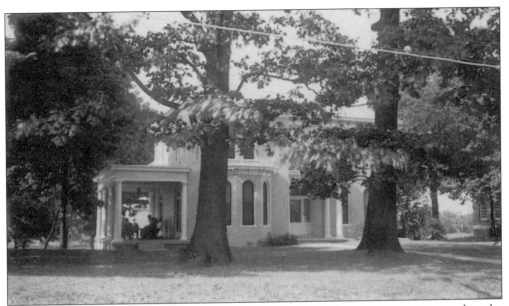

This home on College Street was constructed in the 1870s. For many years, it served as the home for the president of Austin Peay State University, and prior to that, Southwestern Presbyterian University. The home was razed in 1967. (AP.)

This photograph of the extensive gardens behind the President's Home was taken in the 1940s.

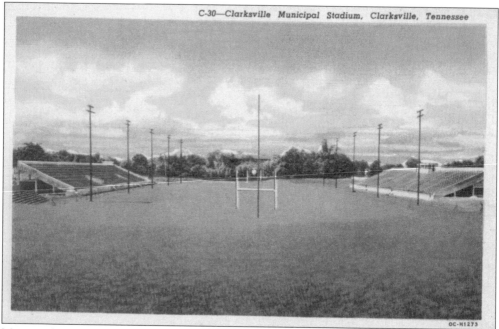

Municipal Stadium was constructed by the city of Clarksville in 1946 on land near the Austin Peay campus. Currently the home field of the Austin Peay football team, Municipal Stadium also served as the home field to a number of local high school teams until the early 1990s.

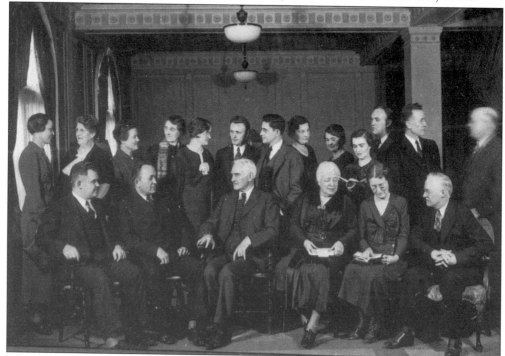

The combined faculty of Austin Peay Normal School and the Demonstration-Practice School, a working school and training facility for education students, gathered in 1937 for this photograph. (AP.)

The National Guard Armory on Marion Street was a 1939 project of the Works Progress Administration. Later acquired as part of the expanding Austin Peay campus, it often hosted many of the school's athletic events. (TSLA.)

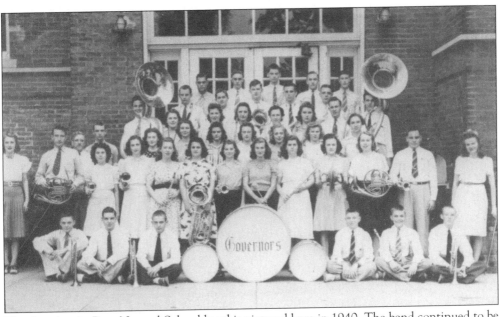

The first Austin Peay Normal School band is pictured here in 1940. The band continued to be a popular organization, and in February 1957 the first Austin Peay band clinic for local high schools took place. (TSLA.)

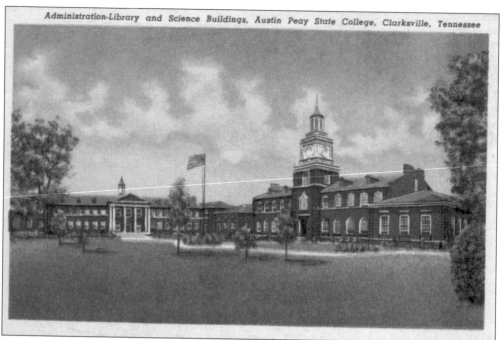

Administration-Library and Science Buildings, Austin Peay State College, Clarksville, Tennessee

This picturesque postcard features Austin Peay State College's McCord Science and Browning Administration and Library Buildings. The McCord Building was constructed in 1949, and the Browning Building was constructed in 1950. In 1943 the school name was changed from Austin Peay Normal School to Austin Peay State College, and in 1966 the school became Austin Peay State University. The school's present library was built in 1968 and was named after Felix G. Woodward, a past professor and dean, in 1971.

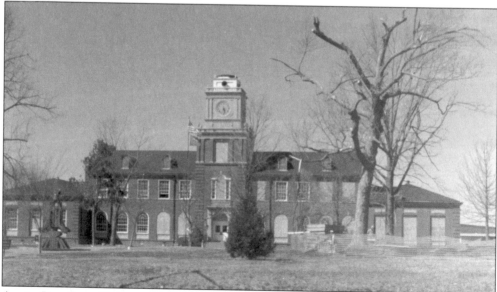

Austin Peay State University was devastated by the January 1999 tornado. The clock tower of the Browning Administration Building, seen in this photograph, was destroyed. Many buildings, classrooms, and dormitories were not safe for the remainder of the semester. Classes continued throughout the city at makeshift locations. (JH.)

Seven

PEOPLE

FAMILIAR FACES OF CLARKSVILLE

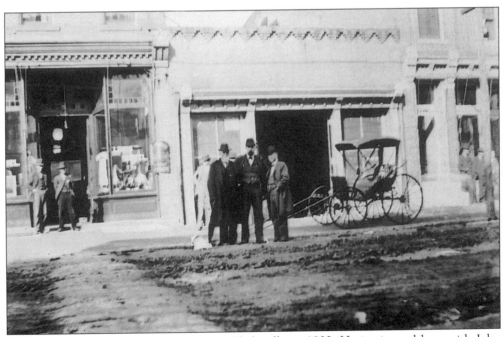

Judge W.B. Young was elected mayor of Clarksville in 1900. He is pictured here with John Shelton and an unidentified individual on the west side of Second Street between Franklin and Commerce Streets. (AP.)

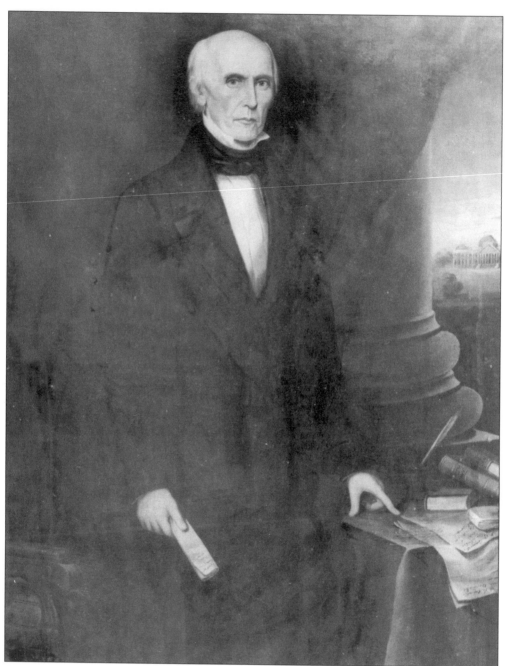

Cave Johnson was born in Robertson County, Tennessee, in 1793. Johnson moved to Clarksville in 1817, and in 1828 he was elected to the United States House of Representatives. Later, Johnson served as a campaign manager for his friend James K. Polk and, upon Polk's election, was named postmaster general. A number of modern reforms were made to the postal service under Johnson's tenure. Adhesive postage stamps and urban mail collection were but a few of the changes that came about. In 1849 following the end of the Polk administration, Johnson returned to Clarksville to practice law. After reluctantly supporting the South in the Civil War and receiving a presidential pardon, Johnson died in 1866. (TSLA.)

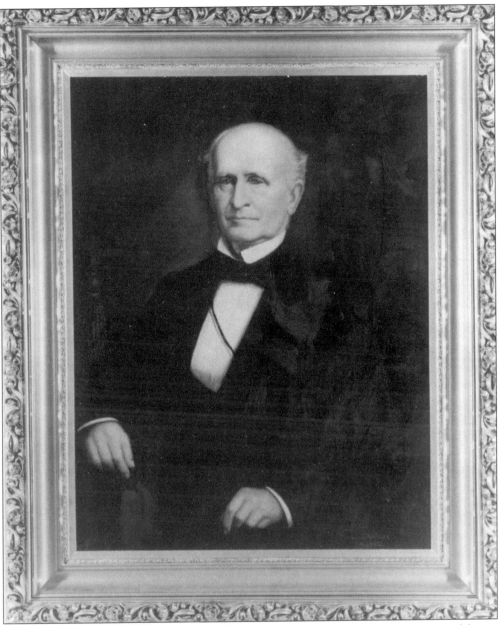

Born and raised in Kentucky, Gustavus A. Henry moved to Clarksville after marrying Marion McClure, a resident of the area. Henry, who had previously served in the Kentucky state legislature and was a gifted orator, became a local leader of the Whig party. Twice, Henry was chosen as a presidential elector—in 1840 for William Henry Harrison and in 1844 for Henry Clay. He served as a member of the Tennessee House of Representatives from 1851 to 1853, when he received his party's nomination for governor. During the Civil War, Henry served as a representative from Tennessee in the Confederate Senate. He died in 1880 at his Emerald Hill home. (TSLA.)

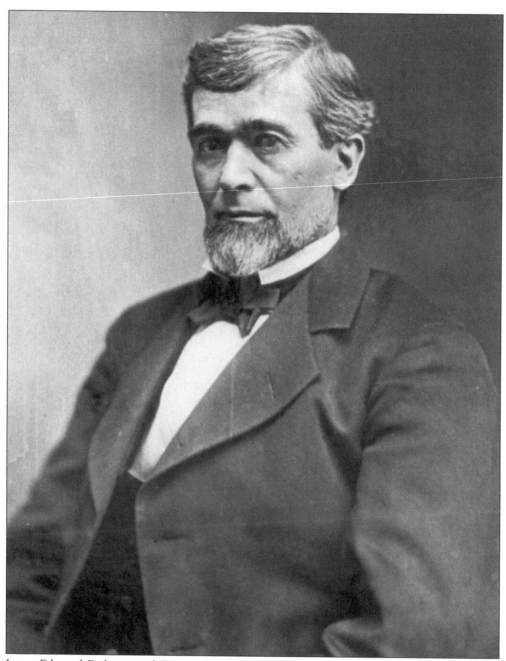

James Edmund Bailey served Tennessee as a member of the United States Senate from 1877 to 1881. Bailey, who was born in Montgomery County on August 15, 1822, served as a colonel in the Confederate Army during the Civil War. A lawyer and member of the Clarksville Bar, Bailey was also a candidate for governor in 1874. (Courtesy of United States Senate Historical Office.)

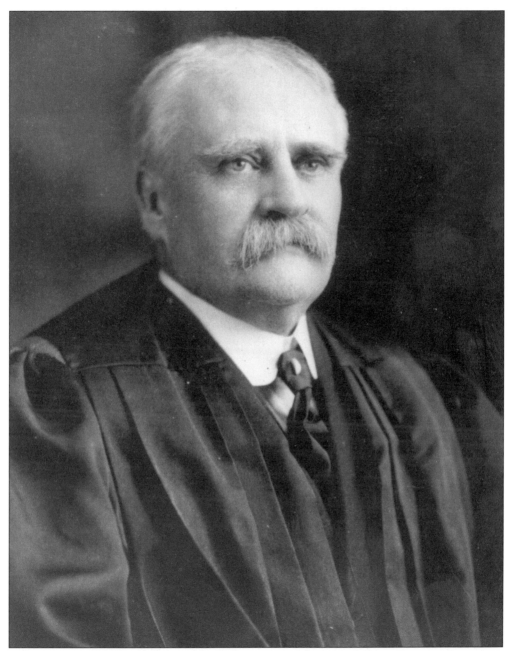

Horace Harmon Lurton served as an associate justice of the United States Supreme Court from 1910 until his death in 1914. Born to an Episcopalian minister in northern Kentucky in 1844, Lurton moved to Clarksville with his family as a child. After a stint as a Confederate soldier during the Civil War, Lurton attended Cumberland University Law School. He practiced law in Clarksville from 1878 to 1886, while residing at a home on the corner of Madison and South Second Streets (the home was destroyed by the 1999 tornado). Lurton's friendship with William Howard Taft, a fellow judge on the United States Court of Appeals for the Sixth Circuit, led to his appointment to the Supreme Court during Taft's presidency. (Courtesy of Collection of the Supreme Court of the United States.)

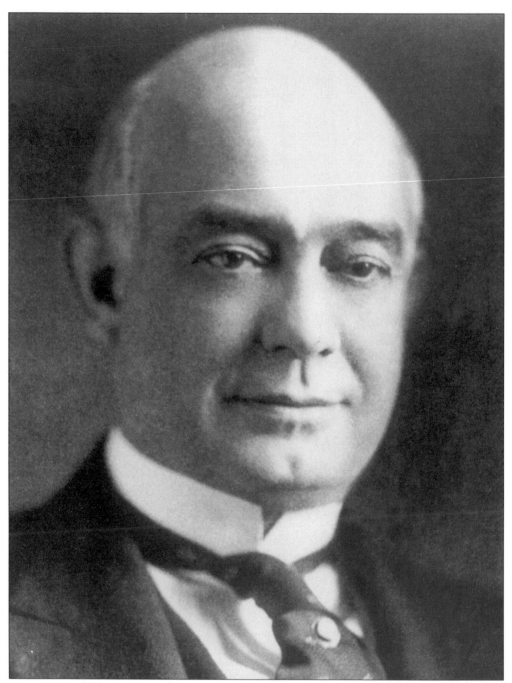

Known as the "Road Building Governor," Austin Peay left one of the most ambitious legacies of any of the state's modern governors. Among Peay's triumphs were improved roadways, a revamped tax system, and the creation of the Great Smoky Mountains National Park. Peay, who served as governor from 1923 to 1927, was born in nearby Christian County, Kentucky, in 1876. After completing the study of law, Peay moved to Clarksville and opened a law practice in 1896. His first taste of elected politics came in 1910, when he was chosen to hold Montgomery County's seat in the state legislature. (TSLA.)

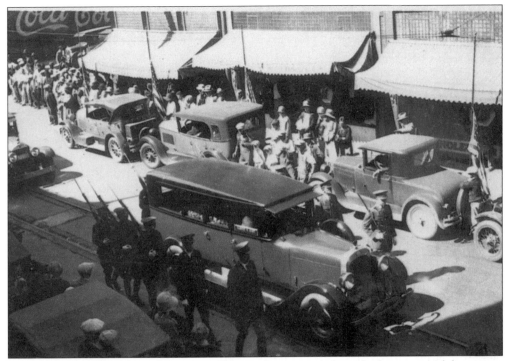

A car carrying the casket of Governor Peay makes its way through the streets of downtown Clarksville on October 5, 1927, three days after Peay's sudden death at the executive residence in Nashville. Peay was the first Tennessee governor to die while in office. (AP.)

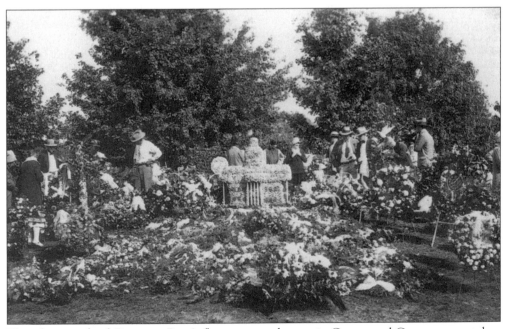

This photograph of Governor Peay's flower-covered grave in Greenwood Cemetery was taken on October 6, 1927, the day after Peay's funeral. (AP.)

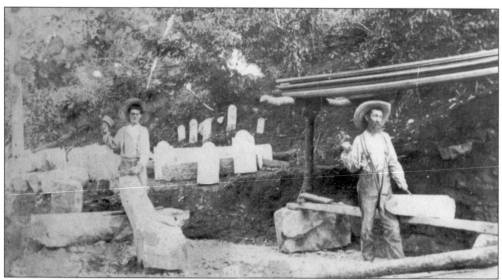

Pictured here are Thomas G. Murff and George P. Murff, a father-and-son team of stone masons. The Murffs chiseled tombstones, gate posts, and well taps from limestone, a type of rock that is plentiful in Montgomery County. This photograph was taken in the early 1900s in the Shady Grove community. (TSLA.)

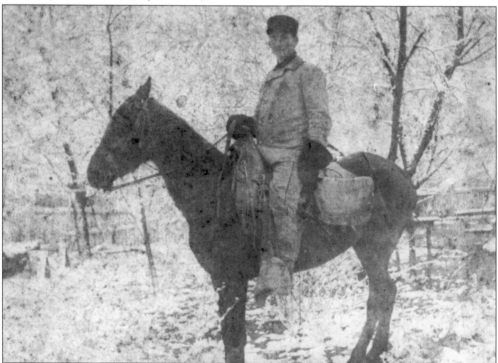

This rural mail carrier, seen on horseback, is delivering mail even with snow on the ground. The tobacco trade in the area increased the amount of mail that came through Montgomery County. This photograph was taken in the late 1800s in the Dotsonville community, when postmen had to supply their own horses for transportation. They also acted as a "moving post office," performing services such as selling stamps. (TSLA.)

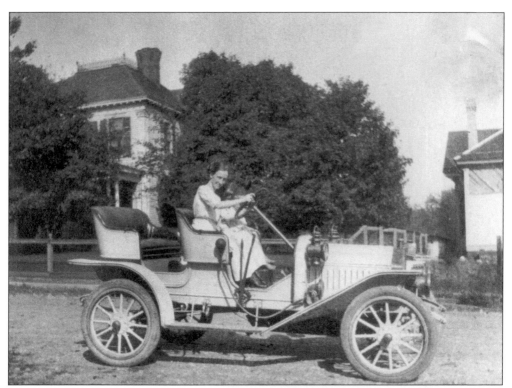

Lucy G. Drane is photographed in 1909 with her Buick near the intersection of Home and West Avenues, which is near the current Austin Peay State University campus. (TSLA.)

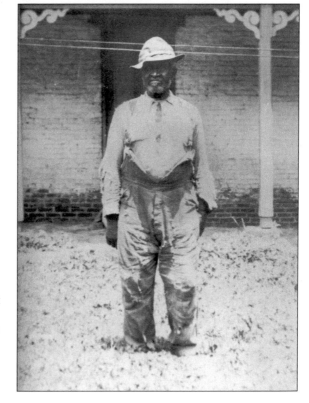

Oak Top is a beautiful residence built in the 1850s and located in the New Providence area. The home was once owned by the Sterling F. Beaumont family. Here a servant, Uncle West, is pictured outside Oak Top around 1915. (TSLA.)

Dr. John H. Ledbetter Sr. was a physician who practiced in the Oakwood Community in Montgomery County. At first he traveled by horse, as pictured here in 1915, and later by motorcycle. He met Myrtle Allen, a school teacher and later his wife, by racing on the road near her school on his motorcycle. (TSLA.)

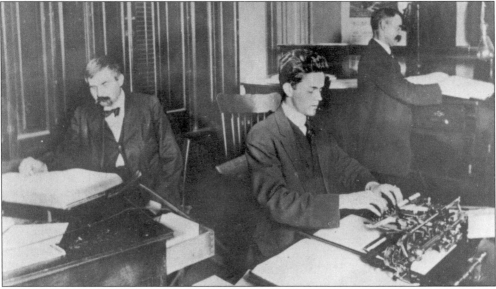

This photograph shows Montgomery County Register's Office employees, from left to right, Charles H. Johnson, Bailey Harper, and Will Rogers hard at work. The photograph was taken in 1915. (TSLA.)

Dr. Ernest Schaffer was a dentist who practiced in the Clarksville area. His office was located on North Second Street. (MB.)

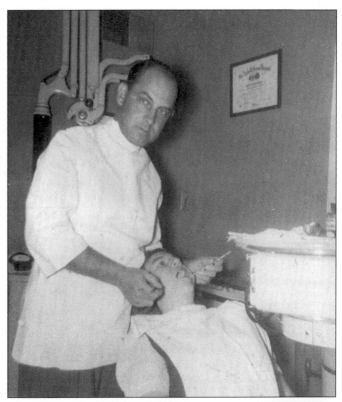

Philander P. Claxton spent 16 years (1930–1946) as president of Austin Peay Normal School. A highly regarded educator and leader, from 1911 to 1921 he served as U.S. commissioner of education in the Taft and Wilson administrations. Claxton continued his strong dedication to Austin Peay by serving as president emeritus during his retirement. (AP.)

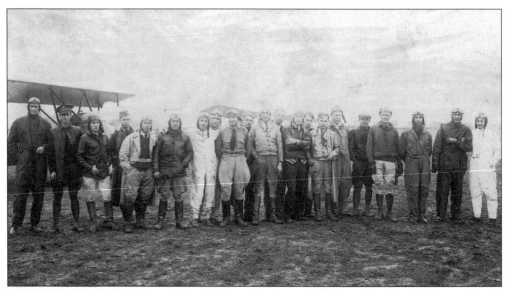

The Clarksville Airport opened in 1929 and was named after John F. Outlaw, an early Clarksville aviator. The land for the airport totaled 225 acres and was purchased from J.C. Caroland. (AP.)

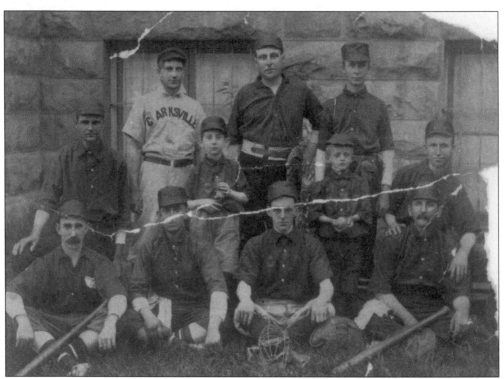

This photograph of the Clarksville Fire Department baseball team was taken near the turn of the century in front of the Montgomery County Courthouse. (TSLA.)

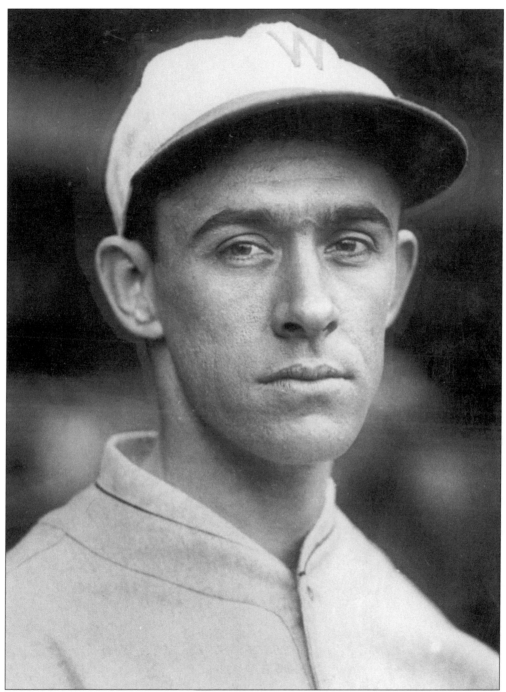

This 1927 photograph depicts Washington Senators rookie pitcher Horace "Hod" Lisenbee. Lisenbee grew up in the Clarksville area and his first experience with baseball did not occur until the age of 21, when he enrolled in Clarksville High School. A 1925 tryout with the Memphis Chicks landed him a spot on that team for two seasons. Lisenbee played for a number of baseball teams and ended up having a long and successful career in the sport. (Courtesy of National Baseball Hall of Fame Library, Cooperstown, NY.)

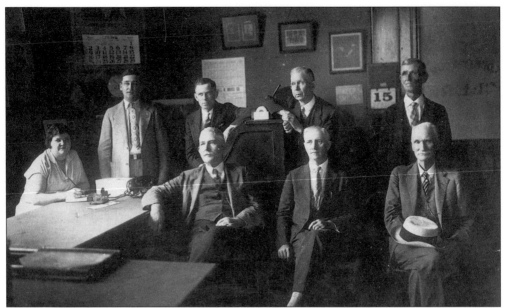

Employees of the Montgomery County Clerk's office pose for a photograph in June 1929. (MB.)

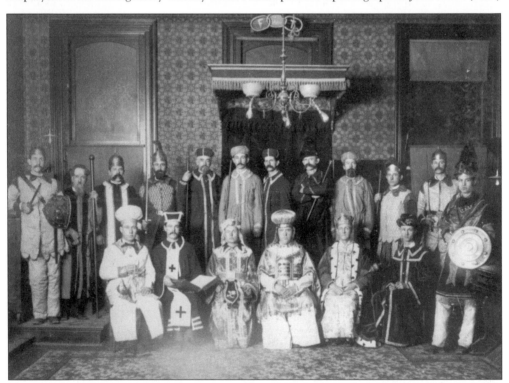

Men are dressed for an unknown pageant in this 1910 photograph. The setting is most likely New Providence's Odd Fellows Home, which was dedicated to the care of orphans and the elderly. The Odd Fellows insignia, located on the light fixture, consists of three intertwined links with "F," "Love," and "T" printed within the links. The symbols stood for friendship, love, and truth. (TSLA.)

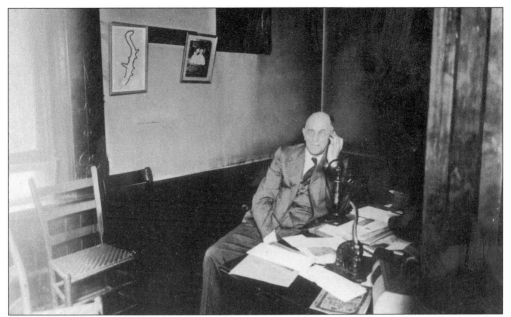

John Talley Cunningham was born in Dickson County and moved to Clarksville with his family at the age of four. He received his bachelor's degree from Southwestern Presbyterian University and his law degree from Vanderbilt University. He was elected to the Tennessee House of Representatives at the age of 28 and later became Speaker of the House at the age of 30. In 1918 he was elected criminal and county court judge; he defeated longtime officeholder Judge C.W. Tyler. (TSLA.)

Judge Cunningham, seen here in his office in the Montgomery County Courthouse, and his assistant, Ms. Genie Farrar, would often entertain this group of men. Nearly every workday, the group would come to listen to Judge Cunningham dispense advice. (TSLA.)

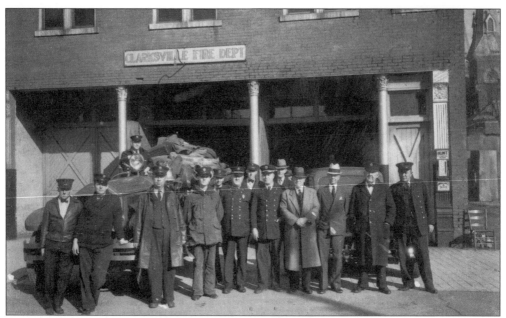

This photograph features Clarksville firefighters, under the direction of Chief John Roache, along with firefighters visiting from another city. (RR.)

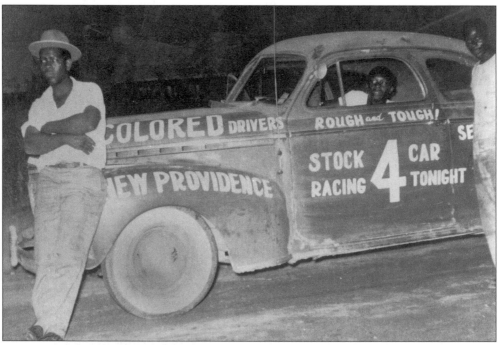

The New Providence Speedway always provided a night of fun. William Cave Johnson Jr. is standing along the front bumper of the car in this 1954 photograph. His father owned an automotive repair shop on Sixth Street. (TSLA.)

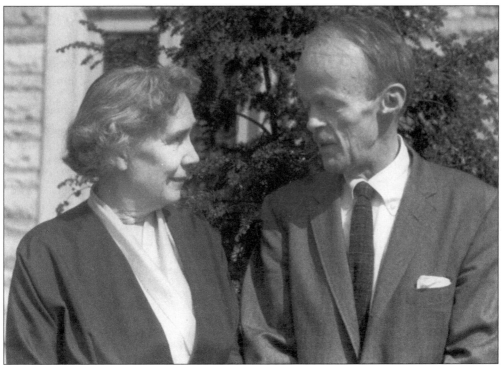

Caroline Gordon (left) was born and raised outside of Clarksville in Todd County, Kentucky. Through Robert Penn Warren, she met Allen Tate (right), and the two later married. Both became notable American writers. After living in cities such as New York, London, and Paris, the couple moved to Clarksville and settled in a house overlooking the Cumberland River known as Benfolly. The house, which still stands today, became a haven for the large circle of writer friends that the couple shared. Gordon and Tate, who in 1946 divorced and later remarried, were permanently divorced in 1959. Both pursued academic appointments throughout the country. Tate died in 1979, while Gordon passed away in 1981. (VU.)

Born in Guthrie, Kentucky, Robert Penn Warren spent time in Clarksville as a student at Clarksville High School in 1920–1921. Warren, who died in 1989, was a highly acclaimed writer. He won three Pulitzer Prizes—two for poetry and one for fiction. This photograph of Warren was taken during his younger years, probably around the time he attended Clarksville High. (VU.)

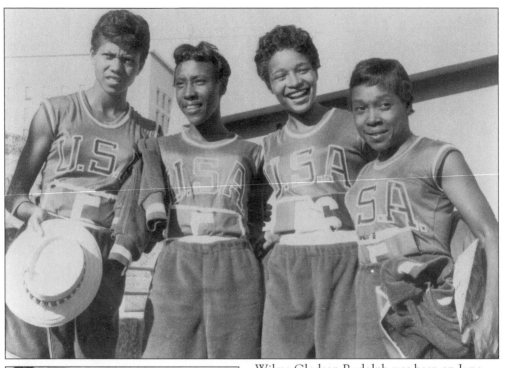

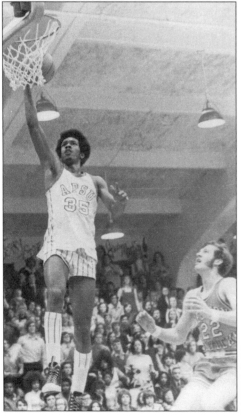

Wilma Glodean Rudolph was born on June 23, 1940, in Clarksville as the 20th child in a family of 22 children. At an early age, she suffered from polio that crippled her left leg and foot. Through treatment at Meharry Hospital in Nashville and with the help of a loving family that performed the necessary physical therapy treatments four times a day, Rudolph eventually overcame her disability to become an Olympic track star. In 1960 at the Olympic Games in Rome, Rudolph (far left) became the first American woman to win three gold medals. She is pictured here with her fellow Olympic and Tennessee State University track teammates. (LOC.)

James "Fly" Williams is arguably Austin Peay State University's most famous alumnus. In 1973 a writer for Sports Illustrated noted that, to locals, Fly Williams ranked "right up there with Fort Campbell . . . and Acme Boot Company" in terms of popularity. Williams played for the Governors for only two seasons, but led the team to the NCAA Mideast Regionals both seasons. He still holds a number of school individual records. (AP.)

ACKNOWLEDGMENTS

Many people have helped make this book a reality, especially since we, as authors, are not full-time Clarksville residents. We are both young writers, fresh out of college and employed at our first jobs in Washington, D.C. We had to travel home for several packed weekends of research to complete this project.

Of the many individuals and groups that assisted us, Mary Bodnar and Randy Rubel opened their homes to us and let us search through their boxes, trunks, and folders. Diane Faires was instrumental in the editorial process of this book. Jeanne Holder donated many of the 1999 tornado photographs, which provided the needed current historical aspect. Elizabeth Kesler at Rhodes College, Kassandra Hassler and Karina McDaniel at Tennessee State Library and Archives, and Elaine Berg at Austin Peay State University provided us with many photographs from their institutions' special collections.

Our families were very encouraging and aided our research by tracking down a number of elusive photographs. We would especially like to thank Joel Wallace's grandmother, Mary Jo Dozier. As a life-long Clarksvillian, downtown small-business owner, and member of the Clarksville City Council, she was an invaluable resource and point of reference.

BIBLIOGRAPHY

Beach, Ursula Smith. *Along the Warioto: A History of Montgomery County, Tennessee.* Nashville: McQuiddy Press, 1964.

Halliburton, John H. *Clarksville Architecture.* Nashville: Parthenon Press, 1977.

McKellar, Kenneth. *Tennessee Senators.* Kingsport: Southern Publishers, 1942.

Titus, W.P. *Picturesque Clarksville, Past and Present.* Clarksville: Wm. P. Titus Publishers, 1887. Reprint, 1976.

Waters, Charles M., ed. *The First Fifty Years of Austin Peay State University.* Clarksville: Austin Peay State University, 1977.

———. *Historic Clarksville: The Bicentennial Story, 1784–1984.* Clarksville: Historic Clarksville Publishing Company, 1983.

West, Carroll Van, ed. *The Tennessee Encyclopedia of History and Culture.* Nashville: Rutledge Hill Press, 1998.

Williams, Eleanor S. *Homes and Happenings.* Oxford, MS: The Guild Bindery Press, 1990.s